the BRITISH LIBRARY
A TREASURE HOUSE OF KNOWLEDGE

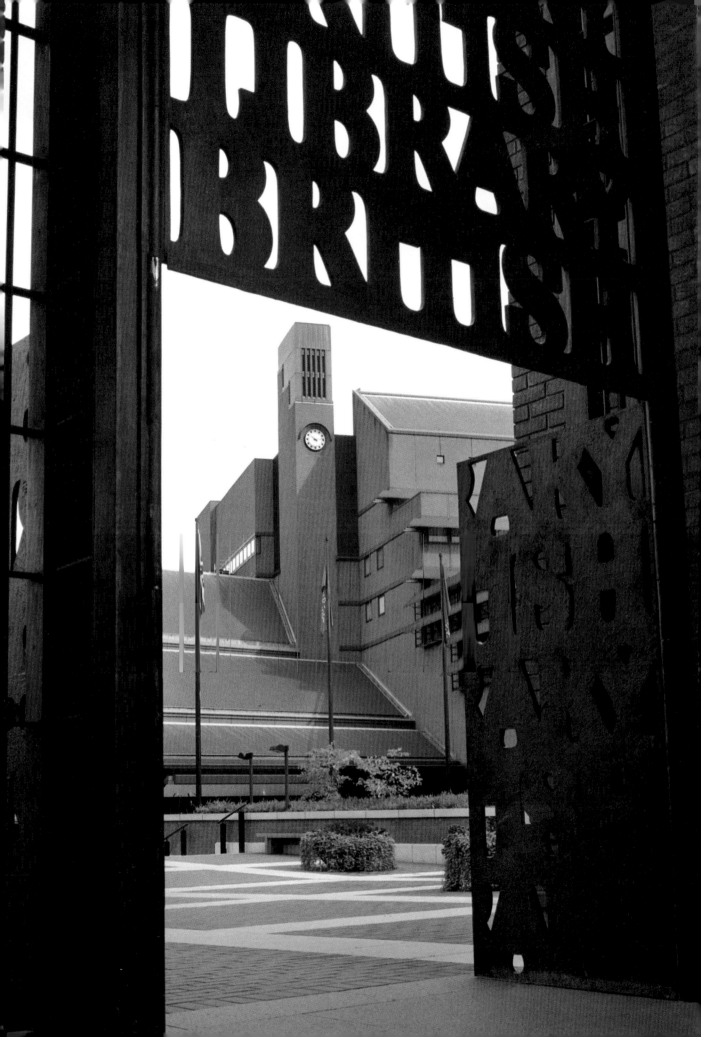

the BRITISH LIBRARY
A TREASURE HOUSE OF KNOWLEDGE

Philip Howard

Scala Publishers Ltd
in association with
The British Library

Illustrations © the British Library, 2008
Text © Philip Howard 2008
This edition © Scala Publishers Ltd 2008

First published in 2008 by
Scala Publishers Ltd
Northburgh House
10 Northburgh Street
London EC1V 0AT, UK
www.scalapublishers.com

in association with
The British Library
96 Euston Road
London NW1 2DB
www.bl.uk

ISBN-13: 978-1-85759-375-4

Designed by Catherine Roylance
Edited by Oliver Craske
with Elizabeth Bacon, Sandra Pisano
Publisher, British Library: David Way

Printed in China
10 9 8 7 6 5 4 3 2 1

Page 2: The British Library viewed
through its principal entrance portico on
Euston Road.

Page 6: Daylight floods into the
Humanities Reading Room through
roof lanterns.

Contents

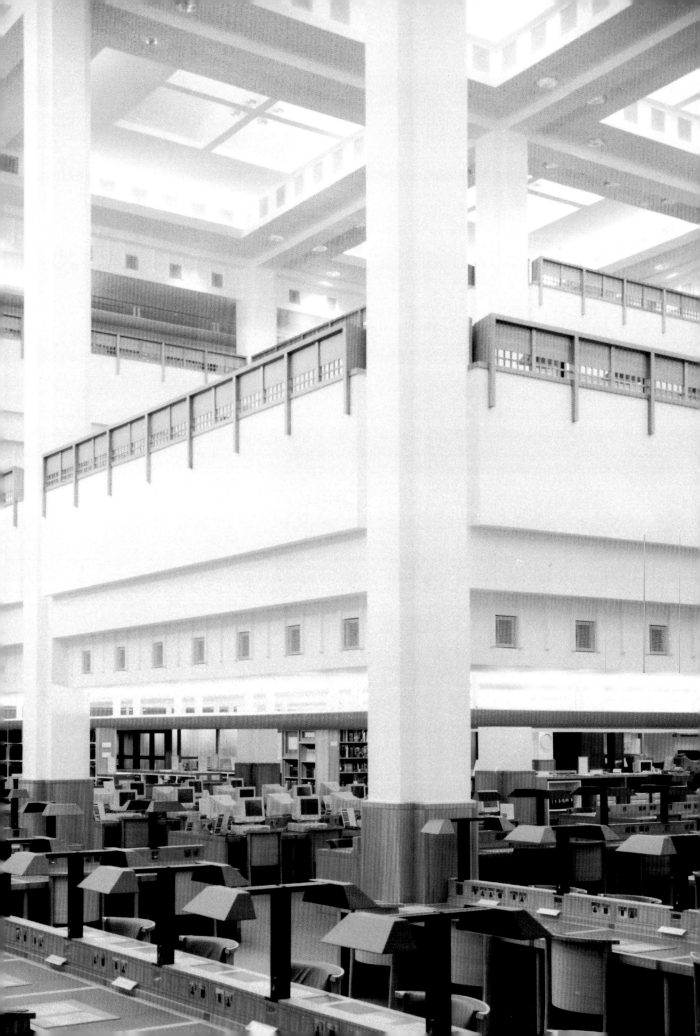

Introduction

A TREASURE HOUSE OF KNOWLEDGE

Welcome to the greatest library in the world. It is not as old as the 10,000 clay tablets inscribed with cuneiform characters and catalogued at Nineveh. It is more universal than the library of Alexandria, which lost half the literature of the ancient world when it was burnt down by crazy murderers of the word. The Library of Congress may be better endowed, and the New York Public Library is almost as big; but neither is a truly international library. Russia and China possess great libraries. But their contents are still obscure to most of the world. Some university libraries, such as the Bodleian, have unique range and riches. But the only rival to the British Library as treasury of the world's knowledge is the Bibliothèque Nationale de France.

There is more to this claim than mere patriotism. Both France and England became united countries and had their revolutions long before other bibliophile nations such as Germany and China, Italy and the United States. Both had extensive empires that brought them into contact with the literature of other cultures. Both have ancient capital cities that centralise knowledge as well as power from the regions. But the private and royal collections that form the original core of the British Library are even older than the French. And English, not French, is becoming the world language.

League tables are less relevant to libraries than they are to football clubs or schools. But the British Library creates superlatives to lead the table and make the head spin. Its collections comprise 150 million items, and rising. These consist not just of books, but also of manuscripts, maps, newspapers, musical scores and recordings, patents, and the new waves of electronic publications. Its treasures span 30 centuries, and come from almost every country and language since man stopped building the Tower of Babel. They include many of the most celebrated documents and publications in the world: the *Lindisfarne Gospels*; the *Diamond Sutra*; the world's earliest printed book; Gutenberg's 42-line Bible, the first western book printed with moveable type; the earlier eastern books; Shakespeare's First Folio; the first edition of *The Times* from 18 March 1788; the books that won the world's literary prizes last year. The historic documents range from *Magna Carta* and a Leonardo da Vinci notebook to the recording of Nelson Mandela's speech at his trial. Leonardo was the last Renaissance Man, whom we credit with knowing everything. But not even Leonardo could comprehend the worldwide knowledge in the British Library.

How did the Bulgars find Christianity? Which books blazed the trail for Roald Dahl? What was the miracle performed by Christ that went unrecorded in the Gospels? Who invented printing by moveable type before Gutenberg? For answers to these puzzling questions, consult books in the Library.

The literary treasures range from the unique first manuscripts of *Beowulf* and *Alice's Adventures Under Ground* to Jane Austen's writing desk and the novel that is going to win this year's Man Booker Prize, the manuscripts of songs the Beatles wrote, and emails from contemporary authors, politicians and scientists. The Sound Archive keeps recordings from nineteenth-century cylinders to DVD and minidisc recordings. You can listen to the voices of W. H. Auden, Queen Victoria and Tennyson, as well as wildlife sounds and hundreds of thousands of music recordings. The British Library is a copyright library. Under United Kingdom Legal Deposit legislation it has to receive a copy of every publication produced in the United Kingdom and Ireland. This means that 100,000 new publications and other items are incorporated every year. And the number is increasing. There are eight million stamps and other philatelic objects in the British Library.

If laid end to end, the shelves that house the collections would stretch from London to Edinburgh. Every year they grow by twelve kilometres. Forty-four metres of new material a day, and rising. If you read five of its books a day, it will take you 80,000 years to read the British Library. And you will then have to start on acquisitions of the last 80,000 years.

The British Library was established in 1973 by an Act of Parliament that brought together a number of famous old institutions into a single organisation. Many of its collections were united 250 years ago as the library departments of the British Museum, with its circular reading room where much history was both written and made. The reading rooms of the new British Library, designed by Professor Sir Colin St John Wilson and Partners, opened in 1998. New ways are being found to accommodate the revolutions of digital publishing from paper to chips. The great red-brick flagship of Britain's national library is the largest public building constructed in the United Kingdom in the twentieth century. It stands beside and complements St Pancras Station, which has itself become a centre of London since the trains from Europe now arrive there. The building too has its superlatives. It has a total floor area of 112,000 square metres spread over fourteen floors – nine above ground and five below. It used ten million bricks and 180,000 tons of concrete. There are seats for 1,200 readers in eleven reading rooms, and nearly 400,000 people use them every year.

Today the British Library faces the greatest change and challenge since Gutenberg. The information technology of computers and the internet means that as much is being published worldwide in a day as was

published in the whole of the fifteenth century. All libraries stand at a crossroads, with forks leading to a future obscured by the fog of new information technology. On one hand this is a populist liberation for Everyman and Everywoman – they can all now publish, instead of the privileged few of before. On the other hand this increases the catchment area for a national library exponentially. It cannot select only the elite which today it judges worthy of preservation. We simply do not know what will be of interest in ten years' time, let alone in a century, or a millennium. Many families were writing letters in the fifteenth century, but only the Paston letters (in the British Library) survive, to open their unique window on the history, politics and language of their age. The British Library has to try to anticipate generations ahead.

But the new technology provides the answer as well as the problem. Without it, libraries would implode under the flood of modern publishing. The book is still one of the most efficient inventions made by man. It can be carried in a pocket or read in a carrel (or a bath) without plugs, ports, noise or assistance. But even the best-bound books decay. And newspapers and journals decay faster. Many of the older items in the British Library are too fragile to read. And they will eventually go the way of all paper: into the eternal dustbin. But words can be transferred to computers. The internet is providing the most revolutionary new medium of publishing since Gutenberg, while the latest pocket computers can carry the texts of hundreds of books. A student can often now read for his or her degree off the internet without ever opening a book. He or she can find the relevant passages by searching the catalogues of the libraries of the world, without librarians, indices or photocopying. By the next generation, most publishing will be digital.

As usual, the British Library is boldly leading the way into this brave new world. Compact discs and microchips are atoms to store and retrieve compared with the dinosaurs of books and manuscripts. Already publishers are contributing their new titles to the Library's electronic archive. Already 50 million catalogue records for books, maps, manuscripts, journal articles, conference papers, music scores, audio CDs and newspapers are online. The British Library now has its first curator of digital manuscripts. It cannot yet collect the oceans of electronic messages that fly through Cyberspace. But it can take what archaeologists call a *sondage* (a deep cut to represent what lies on either side) of a day on the web.

The challenge is vast. But then so is the opportunity. If a runaway comet were to destroy the Earth and all it contains, and only one 'object' were allowed to survive, as a representative memorial of humanity, the British Library not only holds the explanation for the rogue comet – it is the obvious choice to preserve as the last and greatest repository of the knowledge of the world.

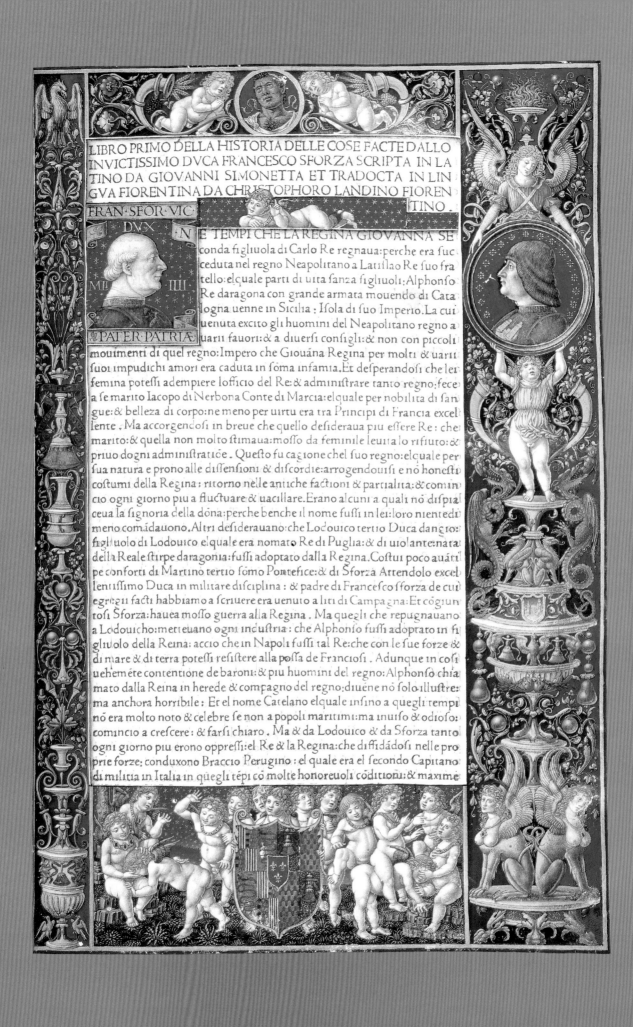

LIBRO PRIMO DELLA HISTORIA DELLE COSE FACTE DALLO INVICTISSIMO DVCA FRANCESCO SFORZA SCRIPTA IN LATINO DA GIOVANNI SIMONETTA ET TRADOCTA IN LINGVA FIORENTINA DA CHRISTOPHORO LANDINO FIORENTINO.

FRAN·SFOR·VIC
DVX
MII·IIII
PATER PATRIÆ

NE TEMPI CHE LA REGINA GIOVANNA SE
conda figliuola di Carlo Re regnaua: perche era suc
ceduta nel regno Neapolitano a Latislao Re suo fra
tello: elquale parti di uita sanza figliuoli: Alphonso
Re daragona con grande armata mouendo di Cata
logna uenne in Sicilia: Isola di suo Imperio. La cui
uenuta excito gli huomini del Neapolitano regno a
uarii fauori: & a diuersi consigli: & non con piccoli
mouimenti di quel regno: Impero che Giouana Regina per molti & uarii
suoi impudichi amori era caduta in soma infamia. Et desperandosi che lei
femina potessi adempiere lofficio del Re: & administrare tanto regno: fece
a se marito Iacopo di Nerbona Conte di Marcia: elquale per nobilita di san
gue: & belleza di corpo: ne meno per uirtu era tra Principi di Francia excel
lente. Ma accorgendosi in breue che quello desideraua piu essere Re: che
marito: & quella non molto stimaua: mosso da feminile leuita lo rifiuto: &
priuo dogni administratioe. Questo fu cagione chel suo regno: elquale per
sua natura e prono alle dissensioni & discordie: arrogendouisi e no honesti
costumi della Regina: ritorno nelle antiche factioni & partialita: & comin
cio ogni giorno piu a fluctuare & uacillare. Erano alcuni a quali no dispia
ceua la signoria della dona: perche benche il nome fussi in lei: loro nientedi
meno comadauono. Altri desiderauano: che Lodouico tertio Duca dangio:
figliuolo di Lodouico elquale era nomato Re di Puglia: & di uiolante nata
della Reale stirpe daragonia: fussi adoptato dalla Regina. Costui poco auati
pe conforti di Martino tertio somo Pontefice: & di Sforza Attendolo excel
lentissimo Duca in militare disciplina: & padre di Francesco Sforza de cui
egregii facti habbiamo a scriuere era uenuto a liti di Campagna: Et cogiun
tosi Sforza: hauea mosso guerra alla Regina. Ma quegli che repugnauano
a Lodouicho: metteuano ogni industria: che Alphonso fussi adoptato in fi
gliuolo della Reina: accio che in Napoli fussi tal Re: che con le sue forze &
di mare & di terra potessi resistere alla possa de Franciosi. Adunque in cosi
uehemente contentione de baroni: & piu huomini del regno: Alphonso chia
mato dalla Reina in herede & compagno del regno: diuene no solo illustre:
ma anchora horribile: Et el nome Catelano elquale insino a quegli tempi
no era molto noto & celebre se non a popoli maritimi: ma inuiso & odioso:
comincio a crescere: & farsi chiaro. Ma & da Lodouico & da Sforza tanto
ogni giorno piu erono oppressi: el Re & la Regina: che diffidadosi nelle pro
prie forze: conduxono Braccio Perugino: el quale era el secondo Capitano
di militia in Italia in quegli tepi co molte honoreuoli coditioni: & maxime

01 Illuminated Manuscripts

01

The Szforziada

Frontispiece to Giovanni Simonetta's
'Life of Francesco Sforza'
(An Italian translation from the Latin)
Illuminated by Giovan Pietro Birago,
Milan, 1490
G.7251

Ludovico Sforza (1452–1508), also
known as 'the Moor', was the Duke of
Milan and patron of Leonardo da Vinci.
His artistic, engineering and printing
works made Milan the most glittering
court in Europe. He commissioned
Giovanni Simonetta to write this
laudatory biography of his father
Francesco in 1482 as a demonstration
of his piety and culture, and justification
for his usurpation of the Dukedom in
1494, when he ousted his seven-year-old
nephew, Gian Galeazzo Sforza, from
power. The combination of print and
paint illustrates the transition from
manuscript. Ludovico himself is
depicted in the roundel with his claim
to be Pater Patriae ('Father of the
Country'). Was this scheming
Duke of Milan perhaps a source for
Shakespeare's plot of *The Tempest*?

Photographers, who are today's illuminators, claim that a picture is
worth a thousand words. Pictures are older than writing. You can see
the first deliberate human records in the cave paintings of Lascaux and
Altamira, and ideographs are the origin of writing such as Egyptian
hieroglyphs and Mandarin characters. Stained glass pictures illuminated
the words of religion for the illiterate in places of worship. But the rich
could own their own illuminated manuscripts.

To illuminate signifies (strictly) to embellish a manuscript with colours
and/or gold, and, rarely, with silver. The art existed in antiquity. You
can observe it in fragments of The Egyptian Book of the Dead, and a
fragmentary copy of the illuminated *Iliad* on vellum. But illumination
reached its efflorescence in the brilliant book-ornamentation that was
developed in the Middle Ages. This was a luxury art. Apart from the
scribe-hours needed to copy the manuscript in an elegant and regular
hand, the colours (especially gold) were expensive. Naturally most
of the illuminated manuscripts in Europe and the British Library have
either Christian or royal or aristocratic themes. Opposite you can see
the mission statement and pictures of the most magnificent Duke of
Milan. Astonishingly from the Dark Age, the names of the author, the
translator, the binder and the illuminator of the Lindisfarne Gospels
are recorded. A monk from Winchester called Godeman transcribed the
prayer-book of St Aethelwold, although the brilliant illuminator(s) are,
as usual, anonymous. Christine de Pisan employed her own illuminators
in her workshop. The illuminators of the Bedford Hours were a Parisian
collective led by the Bedford Master.

The Library holds illuminated manuscripts from farther afield than
Western Europe. The Glorification of the Great Goddess (fig. 26) comes
from Nepal. Lesser mortals and demons are illuminated in scarlets and
gold – but Vishnu, as the Supreme Principle of the Universe, gets the
lapis lazuli treatment. A Bulgarian scribe called Simeon both transcribed
and illuminated the Gospels of Tsar Ivan Alexander (fig. 14). The
illuminated manuscripts in the Library are a treasury of extravagant
high art as well as literature and scholarship.

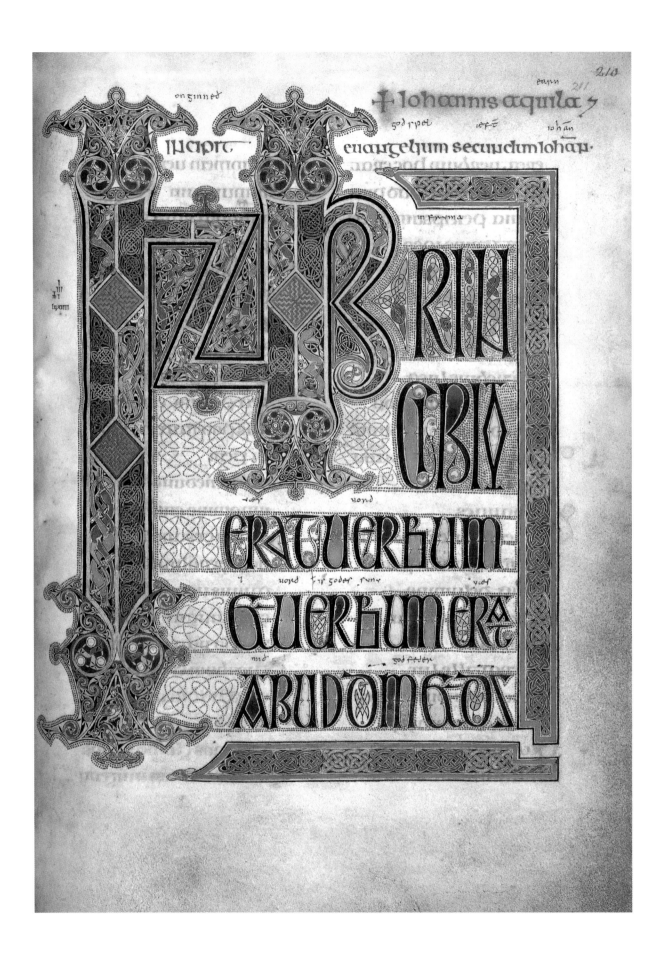

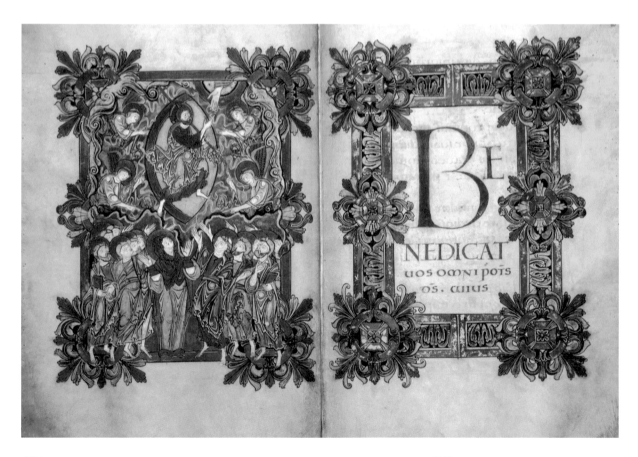

<< 02
The Lindisfarne Gospels
Opening of the Gospel of St John
Lindisfarne, *c.*715–20
Cotton MS Nero D.IV, f. 211

03
The Benedictional of St Aethelwold
The Ascension
Winchester, *c.*970–80
Add. MS 49598, ff. 64v–65

This manuscript of the four gospels in the Vulgate text (St Jerome's Latin version) turns a flashlight on the darkness of England in the eighth century AD. The colophon (signing-off inscription) dates it to the canonisation of St Cuthbert in 698. It also names the author (Eadfrith, bishop of Lindisfarne), the binder, the goldsmith who ornamented the binding, and the translator, Aldred of Chester-le-Street, who 250 years after its creation added an Anglo-Saxon translation between the Latin lines. This is the first extant version of the gospels in English. The colours are derived from animal, vegetable and mineral, and include red, blue, yellow, indigo, pinks and purples. The illuminations and decorative capitals reflect other contemporary arts such as jewellery and enamel work found at the burial of King Radwald at Sutton Hoo in Suffolk around AD 625. The portraits of the evangelists are adapted from Mediterranean models. The decoration fuses Celtic motifs, such as spirals and trumpets, with animal ones derived from Germanic metalwork. This is, in effect, a foundation document of English language, art, Christianity and history. Later it would help found another great institution, when the treasures of Sir Robert Cotton (1571–1631), left to the nation by his grandson in 1702, became one of the three great manuscript collections that formed the new British Museum Library in 1753.

Aethelwold, Bishop of Winchester from 963 to 984, led the monastic revival, and was a patron of the arts and a skilled worker in precious metals. This book of prayers was transcribed for him by a monk named Godeman, who was apparently his personal chaplain. The prayers for saints' days include one for St Swithun, patron of Winchester and in folklore the first weatherman:

St Swithun's day, gif ye do rain, for forty days it will remain;
St Swithun's day an ye be fair, for forty days 'twill rain nae mair.

This frontispiece shows Christ ascending into heaven, waved off by saints, escorted by angels, and welcomed by the right hand of his father. The text says, in Latin, 'May the Almighty bless you, whose…'

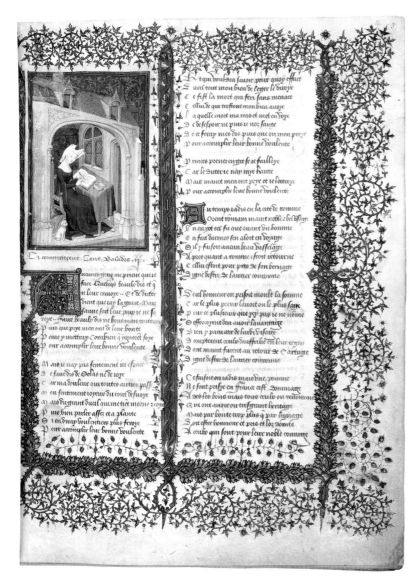

04
Christine de Pisan
Cité des Dames, c.1410–15
Harley MS 4431, part I, ff. 3v–4

Christine de Pisan (1364–1431) is one of the most celebrated French poets of the Middle Ages. She was a courtier whose father, an Italian astrologer, had been head-hunted by King Charles V of France. When she was widowed, Christine supported herself and her three children by her pen – probably the first woman to do so. Her poignant love poems gave way to religious and philosophical works, including essays on the rights of women, and advice to her son on how to survive at the top. While most contemporary authors dictated their works, Christine and her team of professional scribes and artists prepared hand-made copies of her writings. This, the largest surviving manuscript of her works, was presented to Queen Isabeau of France. The opening shows Christine scribbling in her study, with her little dog at her feet.

05 >>
The Bedford Hours
The Legend of the Fleurs de Lys
Paris, early fifteenth century
Add. MS 18850, f. 288v

A Book of Hours is an illustrated prayer-book based on the priest's breviary and ordered according to the hours of the divine office in monasteries. This lavishly illustrated example was owned by John, Duke of Bedford, younger brother of Henry V. The Duke, who captured Joan of Arc and had her burned at the stake, spent much of his life campaigning to hold the British possessions in France. A Paris workshop (known as the Bedford Master) produced this manuscript which was used to celebrate the wedding of the Duke to Anne of Burgundy, 13 May 1423. This illustration, of a popular Burgundian legend, tells the story of how the Fleurs de Lys, the royal arms of France, were given by God's angel to the hermit of Joyenval, who in turn entrusts them to Clovis's wife, Clothilda. Clothilda then presents them to her husband, who has newly been converted into a Christian knight.

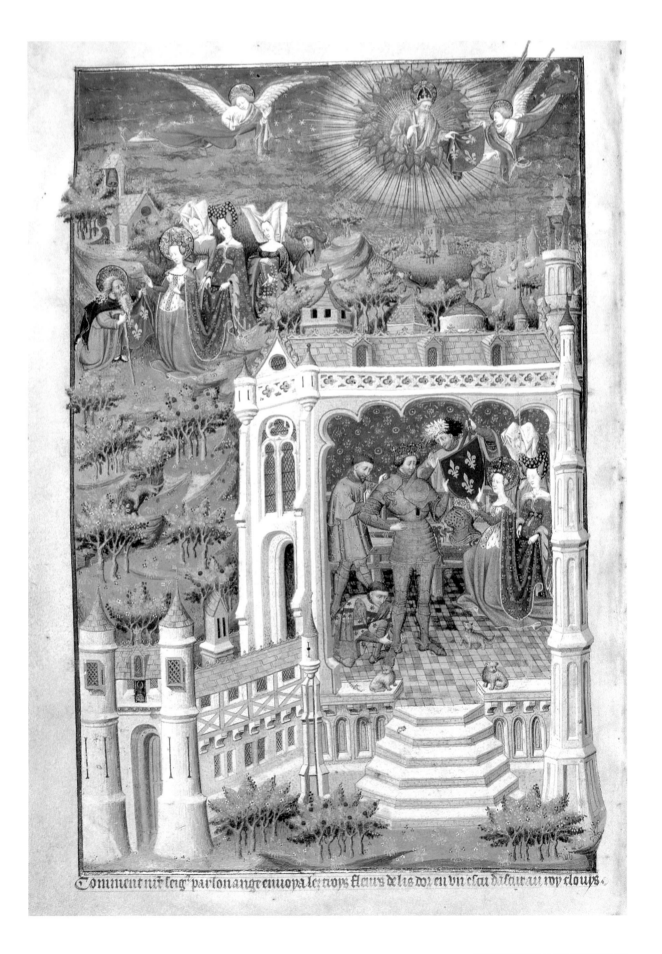

Comment nře seig' par son ange enuoya lec trops fleurs de lis dor en vn escu difair au roy clouys.

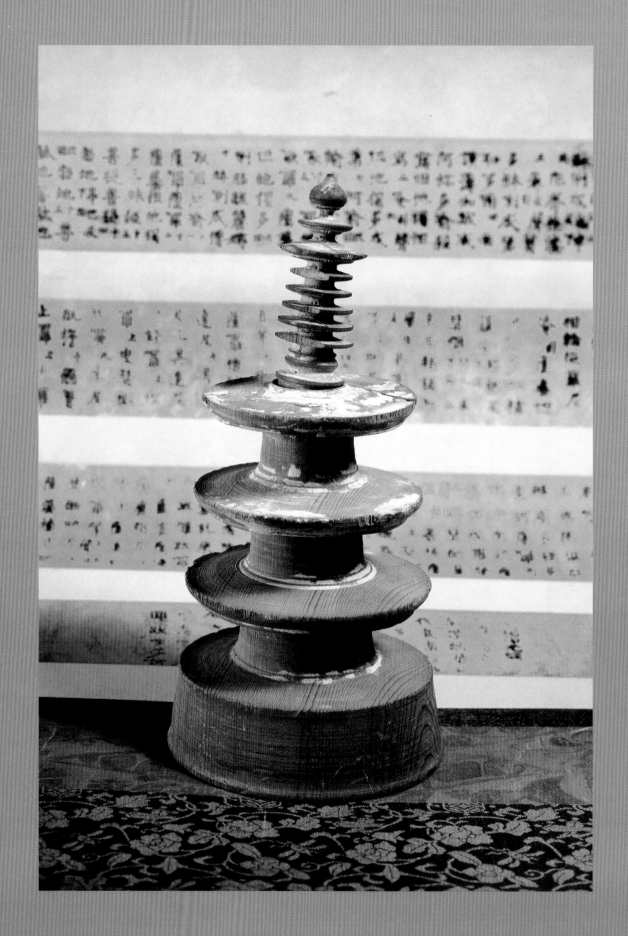

02 Printing

06
The Million Charms
of the Empress Shÿtoku
Nara, Japan, 764–70
Printed mantras in pagoda made
of Japanese cypress and cherrywood
Or.78.a.11 and Or.81.c.31B

After the suppression of the Emi rebellion
in AD 764, the Japanese Empress Shÿtoku
ordered that a million copies of dharani
(mantras) be printed in thanksgiving.
These charms (pictured here in the
background) were distributed, each in
a miniature wooden pagoda made of
Japanese cypress and cherrywood, to the
ten leading Buddhist temples in western
Japan. Until recent discoveries, these were
regarded as the oldest surviving examples
of printing.

Pictures lead to manuscript. Manuscript leads on to printing. Each
of these makes a quantum leap to a new dimension in civilisation. Print
is the art preservative of all the other arts. And the British Library is the
treasury of print.

Printing as western civilisation knows it began in Mainz, Germany.
The definition of printing is itself problematic. Does it mean the printed
book? Or block printing? Or moveable type? Printing needs four
elements to make it possible: type; press; printing ink; and paper. Some
of these were available for the inventors of print. The Chinese were
making paper from fibrous matter by at least the second century BC.
Artists' oil paints were the ancestors of printer's ink. But the invention
of printing was the first example of modern manufacturing techniques:
standardised mass production by means of assembling interchangeable
parts designed and manufactured for precision fit. Silicon Valley was
anticipated in Mainz around 1455. Gutenberg was the first modern
industrial genius. We know nothing about his original press, except that
it was taken from him by his partner as repayment of a debt. Only 48
copies of his 42-line Bible are known to have survived, of which twelve
are printed on vellum and 36 on paper. Twenty are complete, two of
them at the Library. Many, including the Library's lavish paper copy,
married the new technology of print with the old art of illuminated
manuscript. The quality sets standards for book production that are
still unsurpassed.

But a century before, and half a world away to the East, Korean
metalworkers had invented moveable type. Archaeologists have been
discovering their work for the past century. It comes from lost cities and
tombs on the Silk Road. Most of it was found in the walled-up Library
Cave of the Thousand Buddhas, near Dunhuang in north-west China.
It is printed in 20 different languages, from Chinese to Sanskrit and
Uighur. About 100,000 manuscripts, fragments, paintings, textiles and
other artefacts have so far been recovered. The International Dunhuang
Project, based at the British Library, and undertaken by the world's
leading libraries, is making these texts from the birth of print freely
available on the internet. So the student and the lay person can now
drink deep from the wisdom of mandarins and sages, without having to
travel to the Gobi desert.

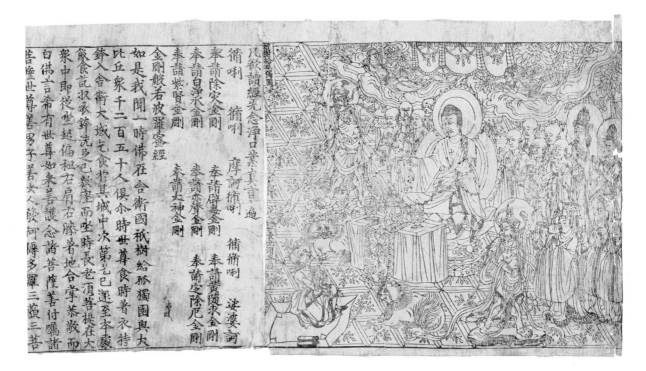

07
The Diamond Sutra
Frontispiece: Buddha preaches
to his disciple Subhuti
China, 11 May 868
Or.8210, p.2

08 >>
**Collected Commentaries
on the Spring and Autumn Annals**
Ch'unch'u kyongjon chiphae
Seoul, 1434
C.16015.c.3, title page

This is the frontispiece of the *Diamond Sutra*, the Buddhist text that is the earliest known printed 'book' in the world. Here, Buddha is preaching to his disciple Subhuti. The book was found in 1907 in a walled-up shaft at the Caves of the Thousand Buddhas, near Dunhuang, in north-west China. The mass of documents inside consisted of about 7,000 relatively complete scrolls and as many fragments. Every scrap of paper predates the earliest paper document in the West, some by seven centuries. Most of them are manuscript, but the *Diamond Sutra* is one of twenty printed documents. It is sixteen feet long, with an elaborate frontispiece and sophisticated text layout. The colophon declares: 'Reverently made for universal free distribution by Wang Jie on behalf of his two parents on the 15th of the 4th moon of the 9th year of Xiantong.' This dates it at 11 May 868. Centuries of British trade with the East and Raj in India brought the book arts of South Asia to the British Library.

Korean metalworkers of the fourteenth century were the world's first printers of moveable type – more than seven decades before Gutenberg printed his Bible in the West. This surviving Buddhist text was printed at a temple in South Korea in 1377. The pages were cast and set in bronze type for the reform programme of King Sejong (reigned 1418–50). The difficulty of importing Chinese texts from China was an incentive for court officials constantly to update and improve printing methods. The achievement was a high-quality type; for example, the kabin typeface shown here.

曰利建侯　音訓　嗣音嗣子也

吉何建非嗣也

子其建之康叔命之二卦告之有建侯之文卦

筮襲於夢武王所用也弗從何爲

弱足者居其跛則偏弱居於不能行侯主

社稷臨祭祀奉民人事鬼神從會朝又爲得居

各以所利不亦可乎

卜襲此於休王祥戎商必克此於武王辭戎商居於元慶居元吉故孔成

不有當位故又無所建從今以位之也二卦皆云

不定卜嗣則當從吉而建之也

有謂再得吉嗣皆必得吉嗣之文卦

子立靈公十二月癸亥葬衛襄公元靈公也

魯昭公三　杜氏盡十二年

經　八年丁卯春陳侯之弟招殺陳世子偃師音訓以稱世子殺例故稱招音韶又招音韶

○叔弓如晉○夏四月辛丑陳侯溺卒

○楚人執陳行人干徵師殺之音訓行人干明旌行人千古丹反○

○秋蒐于紅大蒐車千乘不言...陳公子留出奔

鄭...徵師殺之稱師而出所立未...

於四公蒐于室紅季氏自擇二子至于商一皆衛革征之而貢皆

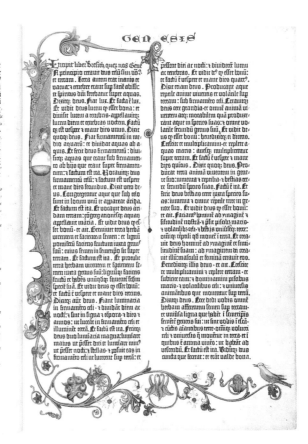

09
The Gutenberg Bible
Jerome's *Prologus* and the opening
of Genesis
Johann Gutenberg, Johan Fust and
Peter Schoeffer, Mainz, 1455
C.9.d.4, ff. 4v–5

10 >>
**The First Privately Printed
English Book**
Matthew Parker, *De Antiquitate
Britannicae Ecclesiae*, London, 1572
Upper cover
C.24.b.8

This is not only the first printed Bible but the world's first mass-produced book. About 180 copies were printed in Mainz in 1453–55 by Johann Gutenberg, the son of a patrician called Friele Gensfleisch or Gutenberg. Between 1430 and 1444 Gutenberg was in Strasbourg, probably working as a goldsmith, and it is there that he may have taken up printing. Living in Mainz again, circa 1450, he entered into partnership with Johann Fust who financed a printing press. His Gutenberg Bible, also known as the Mazarin Bible because the first copy went into the library of Cardinal Mazarin, was a three-volume Latin work printed in columns of 42 lines;

hence its other name, the 42-Line Bible. It comprises more than 1280 pages. This copy was printed on paper in a German Gothic type style. The British Library also holds one of only four known complete copies printed on vellum (calf's skin). This Bible marries the new technology with the old: its decorations painted by hand in England imitate an illuminated manuscript. For example, the birds and flowers that illustrate Genesis suggest the Garden of Eden. The text is quite legible, and is made clearer by the use of highlighted first letters for new sentences. Gutenberg's invention set the standard for printing in Europe for seven centuries.

Matthew Parker was created Archbishop of Canterbury by Elizabeth I in 1559. He was a scholar, as well as a cautious churchman who adopted the third way between Catholic and Protestant extremists. Parker presented his history of the English Church, possibly the first privately printed English book, to Elizabeth in this masterpiece of bookbinding. The book is bound in green velvet worked with gold and silver threads and coloured silks. The Queen preferred velvet to the many gold-tooled leather bindings she was given. The subject of the design, a deer park, may be a visual pun on Parker's name.

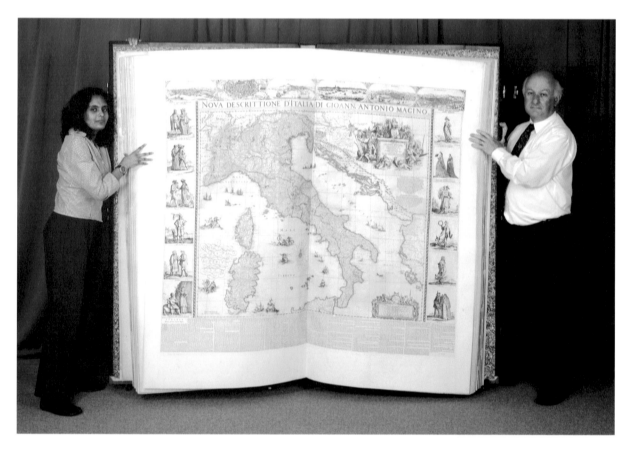

11
The Largest Atlas In The World
The Klenke Atlas, 1613–60
Maps KAR

This colossal atlas was presented to
Charles II (1630–1685) by a consortium
of Dutch merchants on his restoration to
the British throne in May 1660. In return
for creating their maps they were rewarded
with patronage. With British merchant
adventurers emerging as the Netherlands'
principal rival for trade outside Europe,
these Dutch merchants also hoped
for royal support in their struggle for
commercial advantages. Inside there are
42 printed wall maps by the chief and
master map publishers of the golden age
of Dutch mapmaking. John Evelyn
(1620–1706), the writer, gardener and
diarist, saw it in the 'Cabinet and Closset
of rarities' at Whitehall Palace and
described it as 'A vast book of Mapps
in a Volume of neere 4 yards large.'

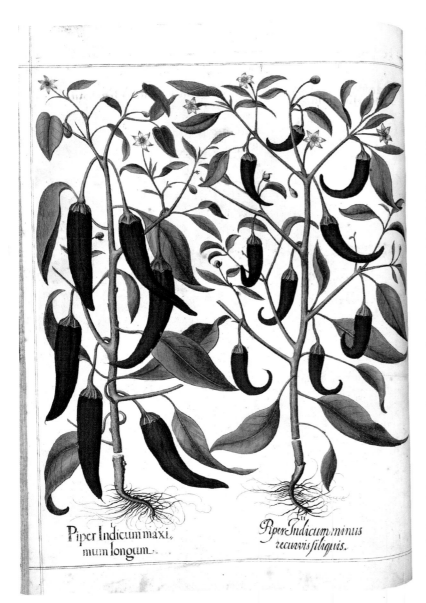

Piper Indicum maxi,
mum longum.

Piper Indicum minus
recurvis siliquis.

12
Red Pepper from the Garden of Eichstätt
Hortus Eystettensis, Basilius Besler, 1613
10.Tab.29

This monumental 'Garden of Eichstätt'
picture book records the garden of the
Prince-Bishop of Eichstätt, Germany,
the first to contain all the shrubs and
flowering plants known at the time.
It was published in 1613 by the botanist-
apothecary Basilius Besler, who had been
involved in the garden's development.
The book contains 367 copper-engraved
plates, and this particular copy, coloured
by George Mack, was owned by George
III before 1780.

13 >>
Anna Atkins's Blueprints
Dictyota dichotoma in the young state,
and in fruit, *c.*1844
From *Photographs of British Algae:
Cyanotype Impressions*
C.192.c.1, vol. 1, part 1, f. 55

This is the matriarch of all photographs.
The cyanotype was an early photographic
process invented by Sir John Herschel
in 1840. He used a mixture of ferric
ammonium citrate and potassium
ferricyanide to produce paper sensitive
to light. The photograph ('light writing')
was made without a camera: a contact
print was produced by placing a negative
or botanical specimen on the sensitised
paper, and exposing it to light. This
relatively simple process was popular
among amateurs in the nineteenth
century, and remains in use by engineers
and architects today for reproducing
technical drawings. The common name
for the process is blueprint. The English
botanist and photographer Anna Atkins
(1799–1871) perfected Herschel's process.
This image is one of a large collection that
she produced between 1843 and 1853 and
compiled in a book entitled *Photographs of
British Algae: Cyanotype Impressions*. It was
the first book illustrated exclusively with
photographic images. Only about twelve
books were produced, and the British
Library holds one of the complete copies.

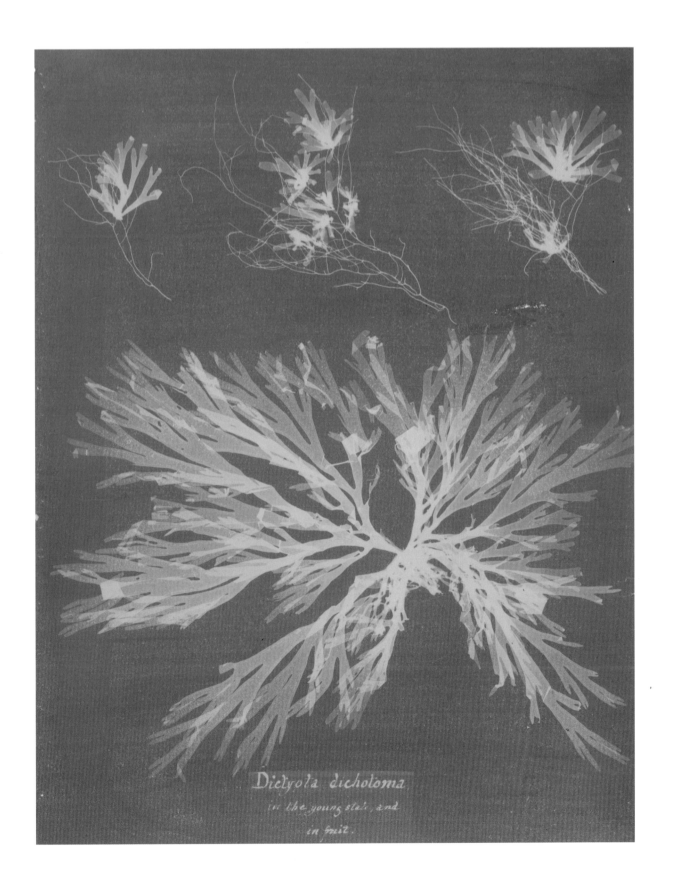

Dictyota dichotoma,
in the young state, and
in fruit.

КОНѦ ВЪ СЕ ЛОУ ЛИ РОУ ВЬ КА Ѥ ТН ТН
ПНШЕ МЫ ХЪ КНИГЪ · АМИНЪ ÷ Є

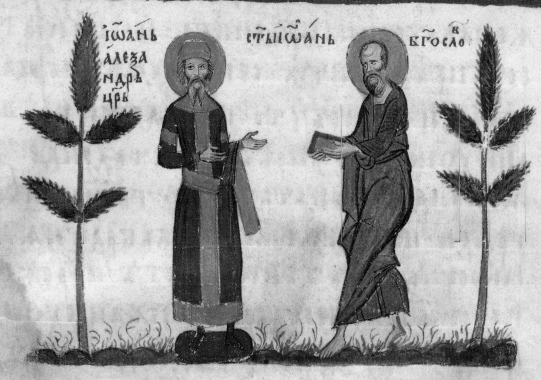

ІѠАНЬ
АЛЕЗА
НДРЪ
ЦРЬ

СТЫ ІѠАНЬ Б͠ГОСЛО

03 Gods

14
Gospels Of Tsar Ivan Alexander
Turnovo, Bulgaria, 1355–56
Add. MS 39627, f. 272v

This is the supreme achievement and final flourish of medieval Bulgarian culture, five centuries after the introduction of Christianity and the Cyrillic script. It was scribed by the monk Simeon and illuminated in 1355–56 by a team of artists, with 366 miniatures and a portrait of Tsar Ivan Alexander. When the Tsar died, the Bulgarian Empire collapsed under the invasion of the Ottoman Turks. The manuscript eventually reached the monastery of St Paul on Mount Athos in Greece. The English traveller Robert Curzon chanced upon it when visiting the monastery in 1837, and was mesmerised by it. As he was about to leave the monastery, he was invited to choose a book as a souvenir of his visit, and incredibly the abbot of the monastery agreed to let him take the Gospels of Tsar Ivan Alexander. The manuscript remained in his family until 1917, when it was donated to the British Museum.

In the beginning was the Word. And the Word was with God. And the Word was God. Priests were the first bookmen. They wrote down words even before the housekeepers who kept the accounts of the royal larder and the military scribes who numbered their warlords' soldiers. Because of its complex history, its religious wars, its heresies and orthodoxies, its imperial (ad)ventures, the continual tug between the Church of England and the Church of Rome, and its native curiosity, Britain has become a repository for the earliest and most sacred writings of the world, from Judaism and Christianity to Hinduism, Islam and Buddhism. It is a historical paradox that the sacred foundation documents of so many religions are preserved in the British Library, including the earliest manuscript of the complete New Testament, the most richly decorated of all Jewish prayerbooks, Hindu palm-leaf manuscripts, extraordinary Qur'ans, and probably the oldest Buddhist text in the world. It is impossible to understand and enjoy the history, literature and art of the United Kingdom without knowledge of these sacred books from the Earth's round corners.

Religion is primarily about faith, not literature. But the literature promotes and supports the faith. So, in the Library, you can read a golden Qur'an; see an early catalogue of the myriad names of Buddha on his road to enlightenment; observe a contemporary view of the miracles of Passover; see the original Ethiopian take on the familiar stories of the Gospels; and read the forgotten masterpiece of modern English, which made the Bible the personal property of Everyman and Everywoman. How does Salome fit into the Nativity story? And why is that shepherd not watching his flocks by night, but cutting their throats? How did the Great Goddess deal with the buffalo-headed demon? Where can you find a medieval missal that survived the Puritan iconoclasm? Which is the earliest manuscript of the New Testament, and why are some of Christ's miracles canonical, while others are not? These may be puzzling questions, but they are not beyond all conjecture. The answers can be found in the Library. Here the Gods of the world's faiths are supported by high art and literature, by manuscript, illumination and print, as well as by belief.

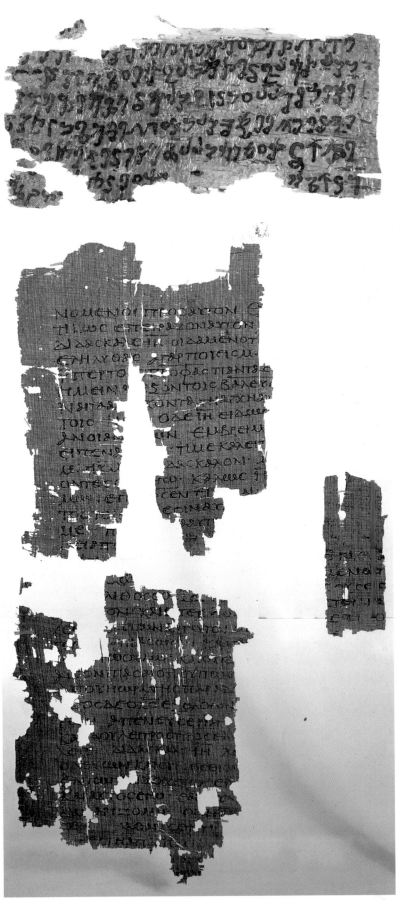

15
Gandharan Buddhist Scrolls
First century
Or. 14915, f. 3r

These scroll fragments, from a hoard of birch bark writings of the first century AD, come from ancient Gandhara and are written in Kharosthi script. They are probably the oldest Buddhist texts, and the oldest South Asian manuscript, yet discovered. Gandhara was a kingdom that straddled modern Pakistan and Afghanistan, and was the crossroads of Indian, Persian and Central Asian cultures. At its peak, from 100 BC to AD 200, it was the world's most important centre of Buddhism, and the gateway through which Buddhism passed from India to China to become a world religion.

16
The Unknown Gospel
Egypt, c.200 AD
Egerton Papyrus 2, recto

These fragments of one of the earliest surviving Christian books, dating from around AD 200, were found in Egypt and obtained by the British Museum in 1934. They contain a hitherto unknown Greek text probably composed around AD 50–100. The Unknown Gospel is unmarked by the heretical doctrines and sensationalism typical of many other non-canonical Christian writings. It may well have been written before the Gospel of St John and it appears to make independent use of the traditional sayings and stories of Jesus that are also found in the other gospel writers. It also contains a mysterious miracle by Jesus that is without parallel in the canonical gospels: the state of the fragment makes the exact story unclear, but it seems to concern Jesus causing fruit to ripen or appear spontaneously.

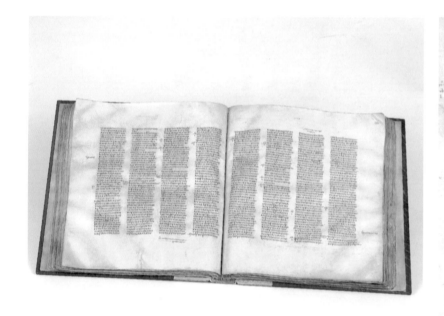

17
The Codex Sinaiticus
Caesarea (?), mid-fourth century
Add. MS 43725, ff. 249v–50

18
Harley Latin Gospels
Gospel of St John, Italy, sixth century
Harley MS 1775, f. 193

This Bible, written in Greek around the middle of the fourth century, is the earliest manuscript of the complete New Testament and the earliest and best witness for half the books of the Old Testament. It is named after the monastery of St Catherine at the foot of Mount Sinai in Egypt, from where it came in 1859. Today, what remains of the original book is divided between four institutions. (A major project is underway to unite them all digitally.) The British Library holds the largest surviving portion (694 pages), which was purchased for the nation in 1933 from the Imperial Russian Library in St Petersburg. Stalin's Soviet government was desperate for foreign currency. It is written on vellum, four columns to the page, and in quires of eight leaves. Three hands took part in the original writing, and the text has been revised by a number of correctors. Although the text seems to be Egyptian, it is uncertain where it was written. The Bible was in circulation in Caesarea by the sixth century. This manuscript revolutionised the study of the New Testament, and has had a decisive influence on many translations of the Bible. It is a landmark in the history of books.

Robert Harley, First Earl of Oxford, was Chief Minister to Queen Anne before being imprisoned in the Tower of London for treason in 1715. A distinguished politician and patron of the arts, he used his wealth and power to amass an unrivalled personal library. His large collection of manuscripts and books was a foundation collection of the British Museum. This is one of the earliest manuscripts of the Gospels in Latin. It is written in an uncial script (one with large rounded characters). Harley bought it in Holland in 1713 from Jean Aymon, a renegade priest and adventurer who had stolen it from the Royal Library in Paris.

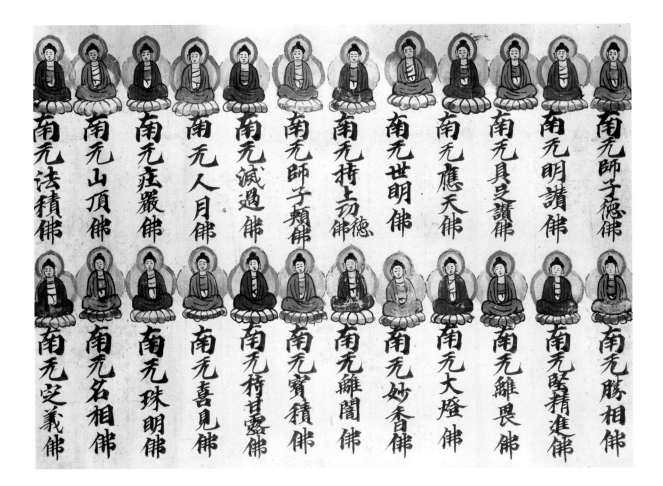

19
Scroll of Buddha's Names
Cave 17, Dunhuang, China
Scroll, ink and pigments on paper, ninth
to tenth century
Or. 8210, S.253

The Buddha is the divine title of Siddhartha Gautama, the founder of Buddhism. He has as many names as legends. Born in Nepal about 565 BC, he is in part a historical figure. He lived in idle luxury, married to Princess Yasudhara with whom he had a son, Rahula. On a day of destiny, 29 years old, he set out on his quest for understanding. After a period of education, which did not bring him the enlightenment he sought, he practised austerity and withdrawal, also without success. Eventually he settled in meditation under a Bo-Tree (or 'bodhi', from the word

for enlightenment). There he achieved 'nirvana', release from the material self, and fulfilled his destiny by becoming the supreme Buddha, or 'Enlightened One'. His doctrine of Dharma proposes the Middle Way between materialism and asceticism. Doing the right thing, without sensual indulgence, may lead to deliverance from the suffering of imprisonment within the cycles of illusory material self-consciousness. This catalogue of Buddha's names represents the emergence of the most pacific of religions. It comes from the Caves of the Thousand Buddhas at

Dunhuang. Marc Aurel Stein, the archaeological explorer, brought it back from Central Asia. The International Dunhuang Project, based at the British Library, is putting more than 100,000 of these manuscripts, fragments, paintings, textiles and other artefacts from Dunhuang and other sites on the Silk Road on the internet. Each scrap of paper predates the earliest paper documents in the West. The project makes life on the Silk Road fifteen centuries ago available for Everyman with a computer, not just for archaeological adventurers.

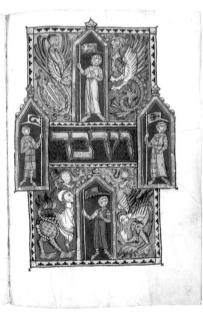

20
The Duke of Sussex's German Pentateuch
Vellum manuscript
Southern Germany, c.1300
Add. MS 15282 ff. 179v–80

The Pentateuch (the Mosaic Law) is part of the Torah, one of the three main sections of the Hebrew Bible. It comprises the first five books of the Old Testament. This manuscript was written and illuminated by a scribe-artist known as Hayyim working in southern Germany around 1300. The Duke of Sussex (1773–1843) was the last owner before the British Museum acquired the manuscript in 1843–45. This double-page spread shows the decorated first word at the beginning of the Book of Numbers, which describes the arrangement of the twelve tribes of Israel into four camps, each with its own banner.

21
The Qur'an of Sultan Baybars
Calligraphy by Muhammad ibn al-Wahid; illumination by Muhammad ibn Mubadir and Aydughdi ibn 'Abd Allah al-Badri
Cairo, 1304
Add. MS 22406, f. 3

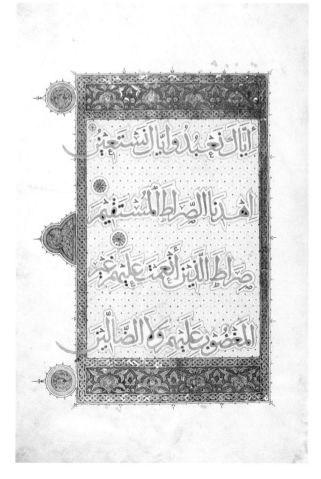

This splendid Qur'an in seven volumes was copied in gold 'thuluth' (cursive) script by Muhammad ibn al-Wahid, the celebrated court calligrapher to Sultan Baybars II, in Cairo, in the year 704 AH (AD 1304). It is his only complete work to have survived. The illumination uses geometrical patterns and ornamental Eastern Kufic script. The vowels are marked in red, and other spelling symbols in blue.

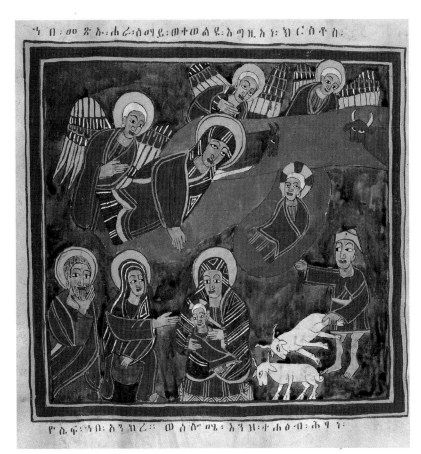

ነበ፡መጽሐራ፡ሰላጓይ፡ወተወልዱ፡እግዚአ፡ነ፡ክርስቶስ፡

የሰፉ፡ናበ፡እንክረ፡ወ፡ሰሎ፡ወሜ፡እንዘ፡ተሐፅብ፡በ፡ሐፃ፡ነ፡

22
The Four Gospels in Classical Ethiopic
Nativity scene
Late seventeenth century
Or. MS 510, f. 100v

The text is in the Gondarine script.
The royal city of Gondar was the capital
of Ethiopia from the sixteenth to the
eighteenth centuries. The patron of this
manuscript was the Emperor Iyasu I
Yohannes, who reigned from 1682 to
1706. Neither the scribe who copied
the text nor the artist who painted the
miniatures is named. This nativity scene
presents details of the birth of Christ as
related in the Gospel of Luke. At the
top, the focus is the Christ Child, who
is surrounded by Mary, three angels and

just the heads of a calf and an ox. In
the lower half of the picture a seated
Virgin Mary holds the Christ child.
The representation of a tender mother
holding her newborn child is a Western
interpretation, and marks a clear depar-
ture from miniatures in the Oriental
tradition. To her left stands Salome,
carrying a clay pot, and Joseph, who
holds his chin in an understandable
gesture of amazement at the events taking
place. At the bottom right a shepherd
offers the sacrifice of two sheep.

23 >>
The Sherborne Missal
Sherborne, c.1400
Add. MS 74236, f. 376

This masterpiece of medieval illumi-
nation is the largest and most lavishly
decorated English service book to survive
the Middle Ages. Nearly all such books
were destroyed or defaced during the
Reformation in the sixteenth century,
or else discarded as unfit for purpose in
subsequent centuries. But this one has
survived for 500 years as good as new. It
was commissioned for the Benedictine
Abbey of Sherborne in Dorset around
1400. This page introduces the common
preface to the mass. Christ appears in two
vignettes. In one he appears in glory, and
in the other he is on the cross. The page
is designed to show the passing from the
Old to the New Testaments through the
sacrifice of Christ on the cross, which is
about to be played out once again in the
celebration of the mass. The importance
of this stage in the service is reinforced
by the architectural feature in which
the Virgin and Child are adored by the
missal's patrons, the abbot of Sherborne
and the bishop of Salisbury.

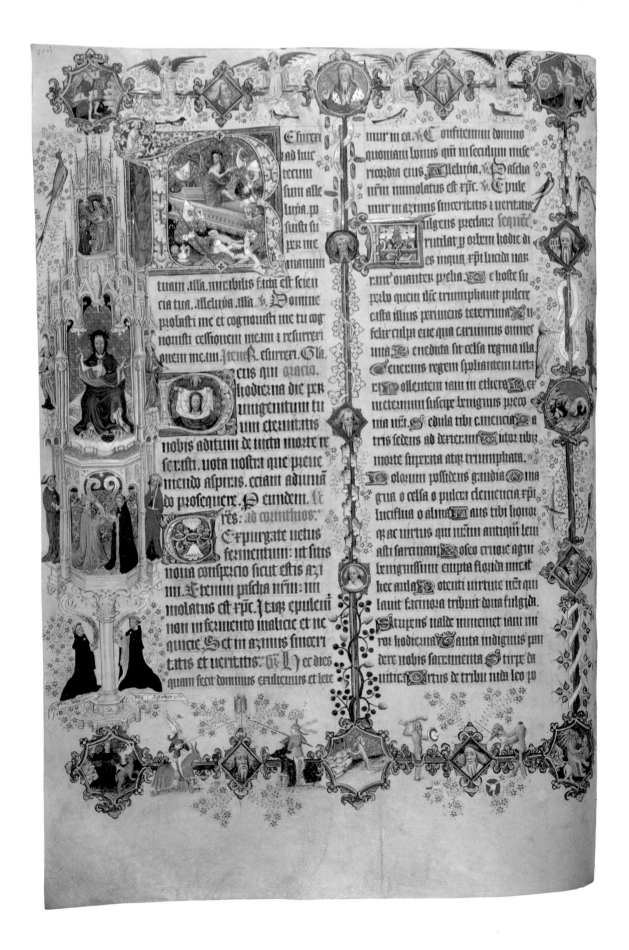

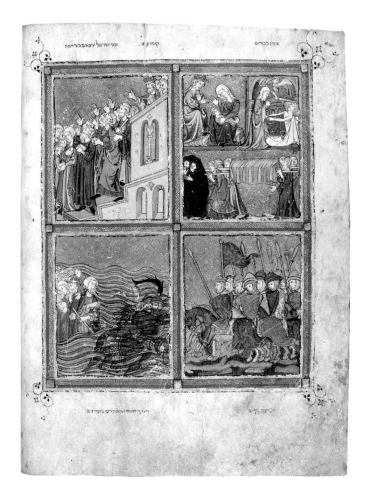

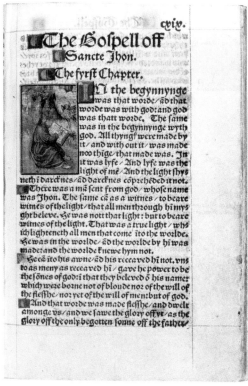

24
The Golden Haggadah
Northern Spain, probably Barcelona, c.1320
Add. MS 27210, f. 14v

The Jewish prayerbook (Haggadah literally means 'narration') tells the story of the divine deliverance of the Children of Israel from their slavery in Egypt and commemorates the Passover Feast. Top right: an angel smites a firstborn with his sword; a mother weeps for her dead baby; the third scene (presumably) depicts the non-canonical funeral of a firstborn. Top left: Pharaoh on his battlement bids the Israelites leave Egypt. Bottom right: the Egyptians, dressed as medieval knights led by a crowned king, pursue them. Bottom left: Moses, holding his rod, turns back to take a last look at the Egyptians drowning in the Red Sea. This, the most richly decorated of Jewish prayerbooks, was written and illuminated by two artists in Barcelona around AD 1320.

25
Tyndale's New Testament
Beginning of Gospel of St John
From *The New Testament*, translated into English by William Tyndale
Printed at Worms by Peter Schoeffer, 1526
C.188.a.17, f. CXIX

This was the first New Testament to be published in English. Such translations into the vernacular were considered heretical by the Pope and his Roman Catholic authorities. But William Tyndale (c.1494–1536) said to an Establishment opponent: 'Ere many years I will cause a boy that driveth the plough shall know more of the scripture than thou doest.' Much of his version was adopted by the translators of the Authorised Version, and so has become part of the bedrock of the English language. This page comes from one of only two complete copies that survive from the several thousand printed in 1526 in the German city of Worms. Such illegal immigrant publications were smuggled into England hidden in bales of cloth. Those caught owning them were punished. At first only the books were burned, but soon heretics were put to the fire also. Tyndale himself was betrayed and burned in 1536. His last words were: 'Lord, open the King of England's eyes!' His New Testament opened the eyes of England for the Reformation. When the Library purchased this copy in 1994, it described it as 'the most important printed book in the English language'.

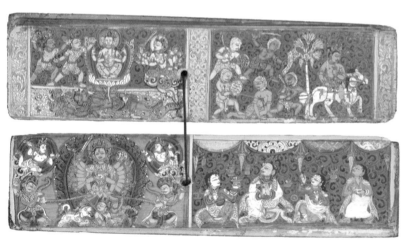

26
The Glorification of the Great Goddess
Unknown artist, Bhaktapur, Nepal, 1549
Or. MS 14325, ff. 1v–2

This palm-leaf manuscript depicts the Devimahatmya, a Sanskrit hymn praising the Hindu deity Devi (the Goddess, known by various names) as the Supreme Principle of the Universe. The song acknowledges the Goddess as encompassing all the other divinities. It was copied in Nepal in Newari script in 1549, and illuminated with miniatures and painted covers for the use of the King Jayapranamalla of Bhaktapur. The upper folio shows Vishnu asleep on the cosmic ocean with Brahma seated on a lotus emerging from his navel. The newly manifested Goddess raises the sleeping God to kill the demons menacing Brahma. To the right, the merchant Samadhi is attacked by robbers hired by his family, and King Suratha rides into exile. The lower folio shows the donor and his family worshipping the Goddess in the act of killing Mahishasura, the buffalo-headed demon.

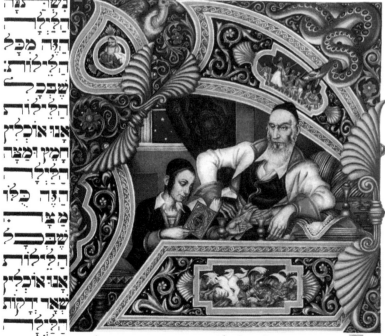

27
Arthur Szyk Haggadah
London, 1940
Or. 70.c.12

This modern Passover Haggadah was illuminated by Arthur Szyk, the Jewish-Polish artist, in 1940. The opening question is: 'What makes this night different from other nights?' The answer is introduced here by the Hebrew initial *mem*. This comprises three miniatures showing the baby Moses, the Israelites' flight from Egypt, and the drowning of the Egyptians in the Red Sea. These sum up the story of the Exodus. The scene inside the letter depicts a Jewish sage explaining the meaning of the Passover festival to a boy. Arthur Szyk drew on medieval paintings and Oriental and contemporary sources to create his Haggadah. The art of illumination lives.

LE JOURNAL D'ABOU NADDARA
(17e Année)

Directeur & Rédacteur en Chef

J. SANUA ABOU NADDARA

6, Rue Geoffroy-Marie, PARIS

Abonnement 26f par An

Tirage justifié 15000 exemp

حريـدة إلى نظـارة

السنـة السابعة عشر

مدير الجريدة ومحررها الاول
الشيخ . سانوا ابو نظاره
نمرو روجوفروا ماري باريس
قيمة الاشتراك فرنك كل سنه

بارس في ١٥ يناير سنة ١٨٩٢

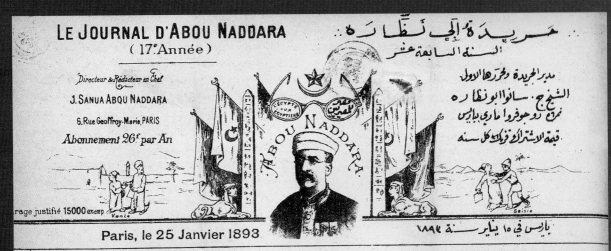

Paris, le 25 Janvier 1893

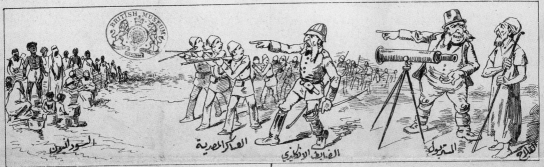

السـودانيـون العسكر المصرية الضـابط الانكليـزي المترول الفلاح

ENCORE LES DERVICHES

Le Fellah : Maintenant que, grâce à la sagesse de notre Khédive, l'ordre est rétabli, tu vas évacuer l'Egypte avec tous tes frères.

John Bull : Nous allions le faire; mais le retour des derviches nous oblige à prolonger notre séjour dans ce pays que nous aimons tant.

Le Fellah : Les malheureux derviches meurent de faim. Le blocus que, vous autres Anglais, avez établi autour de nos frontières confinant au Soudan, les plonge dans la plus affreuse détresse et fait disparaître leur commerce, dont nous profitions aussi. Si les soudanais, que tu appelles derviches, se dirigent vers l'Egypte, ce n'est pas pour l'envahir ni pour faire la guerre à ses enfants qui sont musulmans comme eux, mais pour y chercher des vivres.

John Bull : *Nonsens.* L'Egypte se trouve en face d'un grand danger, et, si nous ne renforçons pas notre corps d'armée, les derviches ne tarderont pas à marcher sur le Caire Les voilà qui attaquent nos soldats égyptiens. Prends mon télescope et regarde.

Le Fellah : Allah me donna une excellente vue; je n'ai pas besoin de ton cristal. Je vois des pauvres soudanais, hommes, femmes et enfants, s'avançant vers leurs frères égyptiens les mains tendues. Ils demandent du pain.

John Bull : Goddem! Non ils ne demandent pas de pain; ils sont armés, et notre intrépide officier a raison de commander à ses hommes de les attaquer.

Le Fellah : Mais *ses hommes*, qui sont nos malheureux enfants, détournent la tête et tirent en l'air : les braves soldats égyptiens préfèrent la mort à l'infamie d'être des fratricides, car les Soudanais sont nos frères. Mais c'est toujours comme ça; toutes les fois que le sultan vous somme, ô Anglais, de remplir vos engagements et d'évacuer notre pays, vous faites attaquer quelques paisibles bandes soudanaises comme celle-ci, qui naturellement se défendent et tue un des vôtres, et alors vous vous servez du prétexte éternel et vous criez « L'Egypte est menacée. »

John Bull : Goddem! Ce n'est pas un prétexte; c'est une réalité. Tant qu'il y aura l'ombre d'un Soudanais dans la vallée du Nil, nous ne la quitterons pas.

Le Fellah : Mais il y a cinq millions de Soudanais dans la vallée du Nil, et, à moins d'un massacre général, on ne pourra jamais les faire disparaître de la surface de la terre.

John Bull : *That is not my business.* Ce n'est pas mon affaire. J'aime ce pays; j'y suis; j'y reste.

Le Fellah : Allah Kerim! Tant que l'Auguste Caliphe et notre cher Abbas vivent et jouissent de la clémence et de la miséricorde d'Allah, nous ne désespérons pas de voir notre patrie délivrée de ses envahisseurs.

John Bull (*riant*) : Espérez; espérez. La Grande-Bretagne vous accorde de longues années d'espoir.

Le Gérant G. LEFEBVRE Imp. Lefebvre frères du Caire 87-89, Paris.

حجة الدراويش

(النص العربي)

AVIS. — Par sa nouvelle méthode, Abou Naddara s'engage à faire parler et comprendre l'Arabe, quel que soit le dialecte, en 3o leçons.

04 Politics & Power

28
Arabic Political Newspaper
Le journal d'Abou Naddarah, Paris,
25 January 1893
14599.e.20

Le journal d'Abou Naddarah was an illustrated political newspaper in Arabic and French, edited by the Egyptian dramatist Yaqub Sanua. It was lithographed in Paris during Sanua's exile there, and smuggled into Egypt. Emigré communities in Europe led the struggle for freedom in the Arab world. Enlivened by cartoons and dramatisations in colloquial Egyptian, the paper gave a relentless satirical critique of the British occupation of Egypt. The newspaper's name was frequently changed, in order to evade the censors. In this issue of 25 January 1893, the cartoon on the front page depicts the infamous Englishman John Bull, the creation of the political satirist and scientist John Arbuthnot (1667–1735). Here he is trying to persuade Egyptian peasants that the Sudanese forces of the Mahdi intend to invade Egypt. It also shows a British officer directing Egyptian soldiers against the Sudanese.

There is more to history than politics. But ever since people started to live together in settled communities, politics has been the scaffolding of their communal life. Politics is what gets recorded, because politicians pay for the official records. History is generally written by the winners and those in power. Britain has a long and turbulent history, written down since the first Roman immigrants imported writing to replace runes. It takes a pride in having no written constitution, as other countries do. But from Magna Carta to tomorrow's Hansard it keeps its record of politics and power.

Magna Carta is not, as is commonly misinterpreted, the original charter for democracy. That was written seventeen centuries earlier in Greece. Magna Carta was an elite treaty between King John and his revolting barons. And it was promptly revoked by the Pope, who had the overlordship of England. But Magna Carta did introduce such revolutionary ideas as the one that nobody should be imprisoned without due process of law. And it marked the beginning of the end of feudal government, and the start of the long march to modern representative democracy. Only four of the letters patent granting the demands of Magna Carta on behalf of King John survive. Two are in the Library.

And so are the records of other critical points in English and British history. So from the Cold War you can see the secret and very detailed Soviet military maps of England. To what end? Here is the final British ultimatum to Hitler, which triggered the Second World War. Karl Marx signs the register for the Round Reading Room of the British Museum, where he wrote, 'From everyone according to his faculties, to everyone according to his needs', and much less quotable else. But the Library also holds the political documents of many other countries, assembled by the extraordinary imperial power and politics of these small islands on the northern fringe of Western civilisation. There are declarations of independence from countries such as Indonesia. Egyptian nationalists campaign against British occupation. And the Athenian constitution records a democracy more complete than anything dreamed of in the philosophy of the framers of Magna Carta. From the documents and printed books in the Library, a scholar from Mars could compile the universal history of the politics and power of this noisy little planet.

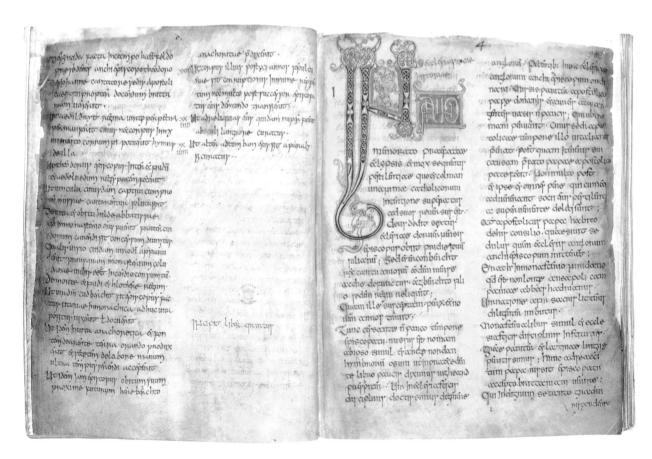

<< 29

The Constitution of Athens
Papyrus CXXXI, Fr 3, col. 12

This papyrus of a previously unknown text attributed to Aristotle was recovered by the Egyptian Exploration Society in 1890. 'Aristotle' lectured from these notes and wrote them around 330 BC, towards the end of his life. It is the first of a collection of 158 accounts of the constitutions of the ancient Greeks. Some scholars believe that Aristotle wrote the *Athenaion Politeia*; but it is inconceivable that he could have written all the works attributed to him. Besides which, he was neither an Athenian nor an admirer of the Athenian democracy. So the work could be more logically attributed to one of Aristotle's pupils. The Constitution tells the story of the momentous transference of power from the kings to the aristocracy and then to the people. Unfortunately the beginning of the work is lost. Originally there must have been kings in the land of the Athenians (*Attike Ge*), for the term for king (*Basileus*) was retained as the name of one of the chief offices (or arkhonships): 'Of these the earliest was the office of Basileus (for it stems from ancestral antiquity) and the second to be established was that of Polemarkhos, because of the inadequacy of some of the Basileis (kings) in matters of war.' This document is the first constitutional history of the first true democracy (though it did leave out women, slaves and immigrants). The reverse of this papyrus carries the detailed accounts of a farm manager in the fields round Hermopolis, Egypt.

30

The Venerable Bede
Ecclesiastical History of the English People
Cotton Tiberius C.ii., ff. 93v–94

The Venerable Bede's work is our principal source for the beginning of English history. It recounts the story of England's conversion to Christianity from the arrival of St Augustine in Kent in AD 597. Bede, who spent his adult life as a monk at Jarrow in Northumbria, was the first great English historical writer, and this is his most famous work. The History tells how Christianity played a vital role in creating a sense of national identity at a time when England was still divided into a number of kingdoms. Bede wrote *Historia Ecclesiastica Gentis Anglorum* (Ecclesiastical History of the English People) in Latin. He finished it in 731. It was later translated into Anglo-Saxon either by, or under, King Alfred. This manuscript was produced in southern England in the early ninth century, within a century of Bede's death in 735.

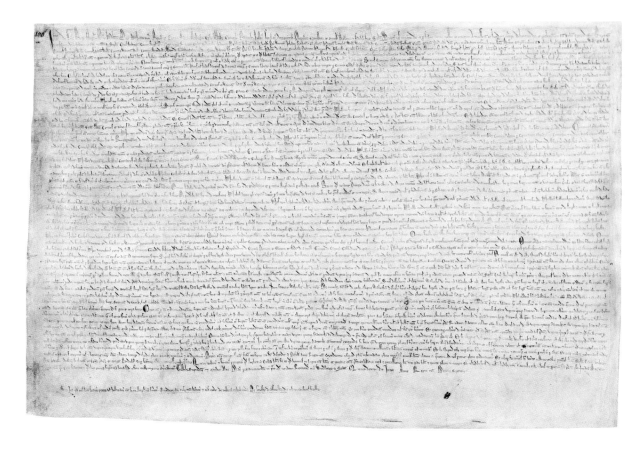

31
Magna Carta
Royal letter promulgating the text
of Magna Carta
England, 1215
Cotton MS Augustus II.106

The Great Charter (or Magna Carta) is one of the world's most important historical documents. It constitutes the foundation of liberty in the English-speaking world. Its 63 clauses, which King John was forced to sign at Runnymede in Surrey in 1215, safeguard the privileges of the church and barons. The King needed their support in order to raise taxes. In return the supporters of the rebellious barons, the citizens of London, had their own privileges confirmed. The Charter is not a law, and says nothing about the rights of the common people. But some of the gains by the elite few were designed to trickle down to the masses. The feudal magnates were obliged to extend the liberties granted to them in turn to their tenants. Here are some mighty principles: the King is forbidden to deny justice to anyone; and no one may be jailed without due process of law. To guarantee this principle, royal judges are to visit each county regularly. From this acorn grew the oak of liberty and democracy. This document is one of the four extant copies, two of which are in the British Library, one in Salisbury Cathedral and one in Lincoln Cathedral.

32
Nelson's Trafalgar Memorandum
Memorandum by Horatio, Viscount
Nelson, off Cadiz, 1805
Add. MS 37953, f. 1

In this unsigned draft, annotated 'Victory off Cadiz 9 October 1805', Nelson explains to his captains his plan for engaging the allied French and Spanish fleet, twelve days before the Battle of Trafalgar. He called it 'the Nelson touch'. His tactic of cutting through the middle of the enemy fleet and polishing off the rear before the van could come to its aid was revolutionary, a masterpiece of naval strategy. It was now that Nelson amused the fleet by using flags for a new 'telegraph' system that spelled out: 'England expects that every man will do his duty.' Trafalgar, along with the repulse of the Spanish Armada and the Battle of Britain, is one of the battles still fixed in the memory of every British schoolchild. Each of them decisively ended a threat of invasion. On all three occasions unbeatable armies were camped across the Channel, requiring only a brief period of localised maritime supremacy to cross the narrow waters. With Napoleon's Grande Armée at Boulogne, the threat in 1805 was the most serious of the three. Although Admiral Lord Jervis said: 'I do not say they cannot come, I only say they cannot come by sea,' Napoleon revealed a good grasp of naval strategy on this, the only time that he turned his attention to it. But when his Admiral Villeneuve reversed direction on the eve of the battle, he made it impossible for his faster ships in the van to come to support his encircled rear. It was a bloody battle. The British suffered 449 dead and 1,214 wounded out of 18,000 engaged on 29 ships. Nelson was killed, and almost a quarter of his captains and their lieutenants fell. The butcher's bill on the other side was huge. Villeneuve's flagship alone suffered 546 casualties, and 18 ships surrendered. Many sank in the storm raging from the Atlantic, and one blew up. The Nelson touch outlined in this memo penned while 'sailing off Cadiz' blew up the plans of 'the Corsican ogre' to invade Britain.

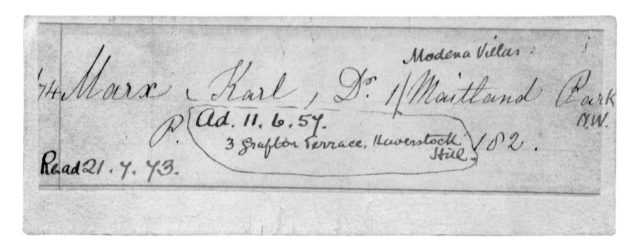

<< 33
Saxton's Atlas
Royal MS 18.D.III, ff. 33v–34

This shows part of Hertfordshire from the first printed atlas of the counties of England and Wales, surveyed by Christopher Saxton, and published in 1579. It is annotated, in his spiky hand, by William Cecil, Lord Burghley (1520–1598), Elizabeth I's chief minister for almost the whole of her long reign. On it he plotted trade routes and military campaigns, but he used it principally for administrative purposes. What were the most densely populated and fertile parts of the kingdom, from which the highest tax returns could be expected? Which loyal members of the gentry should be appointed Justices of the Peace? Where might the enemy land, how good were the defences, and were the families in the vicinity Roman Catholic and therefore potentially disloyal? When in doubt, this first prime minister went to the map, and left his mark.

<< 34
The Marquis de Louvois's Map
Add. MS 64108, ff. 223v–24

Jean-Baptiste Colbert (1619–1683), Louis XIV's powerful minister of finance, and François Michel Le Tellier, Marquis de Louvois (1641–1691), his minister for war, arranged for the best manuscript surveys of fortresses inside and outside France, official and unofficial, by engineers or spies, to be copied in Les Invalides for the personal use of the King and his ministers. Security at court, however, leaked like a colander. This is the manuscript plan of Luxembourg, prepared in the artists' workshop in Les Invalides, and copied by an English spy. The English ambassador in France procured copies of the plans for his King and indicated 'some fortified places which I believe are very exact,' adding, 'If Your Majesty approve of them, I do not question but to have drafts of all the other fortifications of France in a little time.' Using the plans, Charles II enjoyed showing off his knowledge of secret fortifications to his ministers.

35
Marx in the Round Reading Room
Entry of Karl Marx in the British Museum Reading Room's admissions register, 1873.
Add. MS 54579, f. 1

Karl Marx, co-author of *The Communist Manifesto* (1848), was forced into exile in London in 1849 and remained in the city for the rest of his life. He spent many years in the reading rooms of the British Museum (which then housed the British Library collection) working on his most celebrated book *Das Kapital*, most of which was published posthumously. It propounds his theory of political economy, with its most celebrated catchphrase, 'From everyone according to his faculties, to everyone according to his needs.'

On the instructions of H.M. Principal Secretary
of State for Foreign Affairs, I have the honour to
make the following communication.

Early this morning the German Chancellor issued
a proclamation to the German Army which indicated
clearly that he was about to attack Poland.

At this morning the German Chancellor
issued

Information which has reached His Majesty's Government
in the United Kingdom and the French Government indicates
that German troops have crossed the Polish frontier and
that attacks upon Polish towns are proceeding.

If this information is correct it appears to the
Government of the United Kingdom and France that by their
action the German Government have created conditions
(viz. an aggressive act of force against Poland
threatening the independence of Poland) which call for
the implementation by the Governments of the United
Kingdom and France of the undertaking to Poland to come
to her assistance.

I am accordingly to inform Your Excellency that unless
the German Government can immediately satisfy His Majesty's
Government in the United Kingdom that these reports are
unfounded, or in the alternative are prepared to give
His Majesty's Government satisfactory assurances that the
German Government has suspended all aggressive action
against Poland and are prepared promptly to withdraw their
forces from Polish territory, His Majesty's Government
in the United Kingdom will without hesitation fulfil their
obligations to Poland.

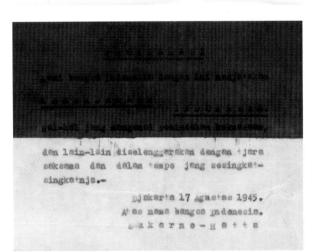

36
The Second World War Ultimatum
Add. MS 56401, f. 161

This is the final British ultimatum, written
by Lord Halifax, the British Foreign
Secretary, that was delivered to Germany
at 9 a.m. on 3 September 1939. The era
of appeasement and procrastination – the
years that the locusts ate, in Churchill's
memorable phrase – had just been ended
by the German invasion of Poland.
The ultimatum was issued for the
best and most foolish of motives – the
horror of another world war. Despite this,
Great Britain and France immediately
declared war on Germany when it rejected
the demands of the British government.

37
Indonesian Declaration
of Independence
Handbill, August 1945
RF.2005.a.465

On 15 August 1945 Japan surrendered
unconditionally in the Netherlands East
Indies at the end of the Second World
War. Since there was no reconquest
of Indonesia by the Allies, the country
was left in political chaos. So Sukarno
(1901–1970) and the other nationalist
leaders drafted this simple declaration
of independence. On the morning of 17
August, Sukarno read it to a small group
of people outside his own house:
'Proclamation: We the people of Indonesia
hereby declare the independence of
Indonesia. Matters concerning the transfer
of power, etc., will be carried out in a
conscientious manner and as speedily
as possible.' The red and white flag was
raised and 'Indonesia Raya' was sung.
This handbill, containing the wording
of Sukarno's declaration of independence
on a background that echoes the national
flag, was distributed in the immediate
aftermath of the event. No similar copies
have been identified. Sukarno became the
country's first president, a position he held
until he was ousted in 1967.

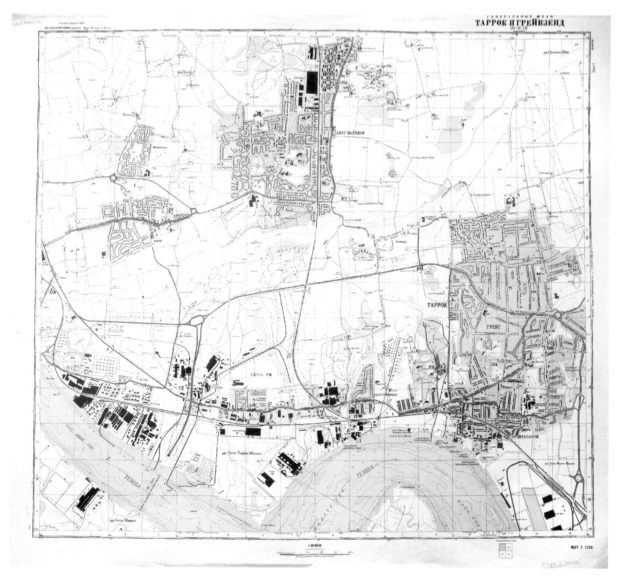

38
Russian Map of the Thames Estuary
Maps X.3250

This 1977 map looks unusual but strangely familiar. It shows parts of Essex and Kent linked across the River Thames by the Dartford Tunnel, but it is in Russian. It was not realised outside the Eastern Bloc that the Soviet military were secretly mapping the world at several scales. Their maps are backed with detailed information, down to the types of trees and the number of telephones in a village. Russian Intelligence transliterated the London place names. Hence, *Temza* for Thames, and *Tarrok* (ТАРРОК) for

Thurrock. Those Ruskies were watching us… Were they planning to mount an invasion? After the fall of Communism, the new Russian government needed cash in a hurry. Suddenly their secret military planning began to appear on the market. At first the sale of maps was cloak-and-dagger. But it also gave map libraries the opportunity to buy coverage of places such as China, India, Africa and the Soviet Union itself, which had been impossible to acquire before.

An Explanation of the Hieroglyphics of the Stone of Rosetta.

ΤΟΝ ΕΜΟΝ ΠΕΠΛΟΝ ΘΝΗΤΟC ΑΠΕΚΑΛΥΨΕΝ.

ℒ. 14, 13, 13, 12, 12, 8, 6 . Εὐχάριστος, ⟨ΥΣΥⲞⲨⳍ, ⲐⲢⲈⲰ⳽ⲚⲈⲤ, or ⲤⲈⲘⲈⳘⲚⲈⲤ, liberal or munificent, giver of good gifts: ‡ in the singular must be good, the plural is made by the repetition. In ℒ.5 seems to be ἀγαθὰ πάντα [‡ occurs in l. 4. 4] again ☿ ⟨5⟩ ἀγάθῃ τύχῃ : ⟅⟆ must be doer or giver.

ℒ. 14, 13, 13, 12, 12, 8. 6 . Ἐπιφάνης, ⳍⲩ, ⲤⲢⳘⲤⳝⳍ, ⲎⳘⲚⲤⳟⲦⲪⲈⲢⲤ, perhaps ⲚⲬⲈⲚⳟⲩⳍⲦ. ⲪⲈⲢⲤ ; illustrious, conspicuous, not simply present, as Heyne is disposed to think: this the Egyptian inscription proves, by the comparison of its parts, without reference to the Coptic. ⲞⲦ or ⲞⲦ is a day. , l. 12, 3 , perhaps honorary.

ℒ. 14, 13, 12, 12, 8, 6 : ℒ.10 Θεὸς, ⳝⲩ, which is rather a hieroglyphic than ⲚⲞⲨⲞⲦ, like ⲚⲞⲦⲦⲈ though it is barely possible that it may have been read ⲚⲞⲦⲦ, and with the frequent addition ιλ, ⲚⲞⲦⲦⲎ. ℒ.8 ΥΓ, perhaps of all the gods, or each god: 8, ΓΓΓ of the gods ; ᵬᵬᵬ , l.5: probably the great gods crowned with asp bearing diadems ; 2ᵬᵬⳝ , 2ᵬᵬⳝ , perhaps derived from this character : , l.4, probably a temple . ℒ. 7 , probably sacred or solemn, from ⲞⲞⲦ ; the three points following a word always making a plural : and in one or two instances preceding a word, after a preposition. Thus ℒ.5 Γⳗ seems to be of the gods. This preposition seems to be the Ⴅ, Ⴉ, or of the Egyptian inscription. ℒ.14 seem to have no other distinguishable meaning than Γ.

ℒ. 14, 12, 7, 6, 6, 6 . surrounding the name of Ptolemy, and sometimes including some of the titles: as an honorary distinction. Thus in the Egyptian the name is generally followed by ΙⲤ or Ⲕ, which appears to be borrowed from this character. In ℒ.6 means sacred to ; Eg. : the character is also found in Egypt.

ℒ. 14, 6 . Probably ἠγαπημένος τῷ ΦⲐⳍ, which occurs in the corresponding place among the titles when fully enumerated: and the character ⳍ resembles the , Phtha or Vulcan in the Egyptian : 8 to or by ; it may also imply something sacred, l.4.4 : but ᵬᵬ seems more likely to imply beloved : in l.14.14 again it seems to answer to a termination , or , l.13 private, ℒ.10, his own : = must be an article. On the Heliopolitan column attributed by them to Sochis we have ᵬᵬ only – so that probably a conjunction.

ℒ.14, 6 . Αἰωνόβιος, , a character pretty obviously borrowed from this : it is true that ⳍ elsewhere means life : but the other parts of the character do not admit of any explanation, nor does ⳍ agree with any Coptic word. ℒ.10 occurs probably in the same sense as an epithet of Γ, or ΙⲤ : , ℒ.5, for ever , εἰς τὸν ἅπαντα χρόνον, ℒ.4 113 . ℒ.5 , probably long life, health, ὑγίειαν : ℒ.5, 5, perhaps Apis.

ℒ. 14, 12, 6, 6, 6 . Ptolemy. The animal seems a lion. The bent staff seems to imply superiority or divinity, being allied to ⳍ life ; and is found, in a contrary direction, in a priest.

ℒ. 14, 7, 6 . Probably young, νέου, ⳝⲭⳟ, the only epithet interposed between king and Ptolemy ⟨ⳘⳏⲞⲦ⟩ : in ℒ.10, probably only . This is the natural inference from the Rosetta inscription only: I have allowed it to stand in the printed translation: but in other inscriptions it is manifestly an insect — and therefore can

ℒ. 14, 10, 10, 9, 7, 6, 5, 2 . King . ⳍⲢ, 10, probably kingdom : ⳍⳍ, 5, the same : bee mention by Horapollo and Ammianus characters

05 Science

39
Thomas Young and the Rosetta Stone
'An Explanation of the Hieroglyphics of the Stone of Rosetta', c.1815–19
Add. MS 27281, f. 41

This is a page from work in progress at deciphering the oldest mystery of antiquity – Egyptian hieroglyphs. The Rosetta Stone, now in the British Museum, was discovered by a squad of Napoleon's soldiers in 1799 in Rashid (Rosetta), a village on a branch of the Nile. It carries a proclamation by Ptolemy V from 196 BC in three scripts: Egyptian hieroglyphic, Egyptian demotic and the Greek alphabet. Thomas Young, the English physicist, physician, Egyptologist and polymath, played a vital role in deciphering the demotic and the hiero‑glyphs on it. This page, from the Library's five‑volume set of Young's Egyptian manuscripts, shows the mind of the code‑breaker at work. Crucial to the decipherment were the cartouches, oval rings enclosing groups of hieroglyphs. The French soldiers named them because they looked like their *cartouches* (cartridges). Young identified the six cartouches containing the name of Ptolemy. Half way down the page he has drawn a picture of a cartouche, and writes: 'L [lines] 14, 12, 7, 6, 6, 6, surrounding the name of Ptolemy, and sometimes including some of the titles: as an honorary distinction.' Three of the cartouches spell the name of Ptolemy phonetically. Three other, longer cartouches spell the name of Ptolemy with his royal title: 'Ptolemy living for ever, beloved of Ptah.' Thus Young began to assign phonetic values to some of the hieroglyphic characters. This was the key that eventually – through the work of Jean‑François Champollion in France – unlocked the Rosetta Stone and the hieroglyphic script.

Britain's two cultures of science and literature meet in the Library. Leonardo da Vinci would not have recognised our modern dichotomy. But the world has grown too wide even for that archetypal and last Renaissance Man. His equivalent now is the Library. In it you can read some of the papers of Leonardo, on every subject from mechanics and flight to art and anatomy: 'The span of a man's outspread arms is equal to his height.' (That is, if you can decipher his left-handed mirror-script written from right to left.)

But the Library is an archive of the science of the world from both before and after Leonardo. Here you can see plans from the dawn of science, and the latest designs for iPods and computers. Here are James Watt's plans for his newly invented steam engine, and Darwin's official record *On the Origin of Species*. This is partly because the Library is the final home of the National Library of Science and Invention, and the Patent Office Library where inventors register the patents of their inventions. The Patent Office Library is the best technical library in the country and, arguably, the world. It is also a record of the ascent of scientific man. Faraday and Franklin, Planck, Einstein and Rutherford all have their inventions registered and their theories recorded here. Here are the foundation documents and plans of electromagnetics, quantum theory, relativity and atomic physics. The modern backseat angel and Siren, Satnav, has her grandmother here. In 1858 Gaspard Félix Tournachon (better known as Nadar) patented the art of aerial photography, the ancestor of today's LANDSAT satellite survey.

The Library inaugurated a system of exchange of patents between countries. This need for international patent protection led to the Wright Brothers registering here (no. 6732 of 19 March 1904) the aeroplane in which they made the first mechanically powered flight. So scientists and students, inventors and wannabees worldwide frequent the Library as the laboratory for their ideas. Here the litigious can check whether their scheme for a windsurfing machine is original. And the romantic can spot a beautiful woman hiding in the craters of man's first proper map of the moon, or see the earliest illustrations of herbs made by co-operation between ancient Greeks and Arabs. The Library is where science meets literature from the wide world.

المعِصر والنَّفخ وَقَد يقطعان القى الذى يعرض من طفوّ الطعام
فى المعِدة وميسال البطن وبدران البَول وسكّا ن
الفَواق وَاذا ادمَن شُربه الشِّبث اضعَف البصَر وقطَع المنى
وَاذا احتبَسَ النِّساءُ طبيِّه انتفَعَن به من اوجاع الرحم وَاذا
احرق مزرّ وضُمِّد على البَواسِير النَّابتة قلعها
لومينون . وَهو الكمّون البستاى

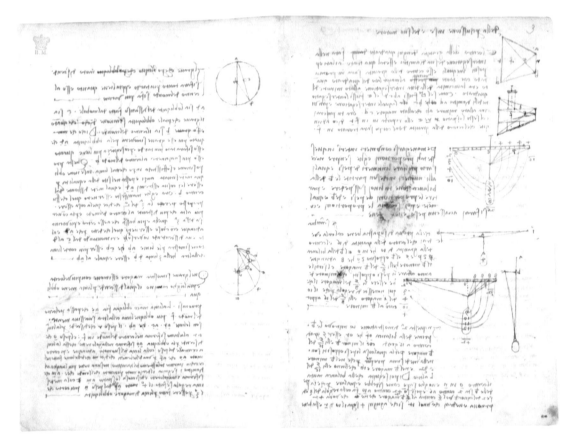

<< 40
Materia Medica of Dioscorides
Arabic translation, Baghdad, 1334
Or. 3366, f. 48

41
The Codex Arundel
Leonardo da Vinci, 1508
Arundel 263, eg ff. 12v–13

This picture of dill is nearly seven centuries old. It comes from an Arabic translation of the most influential herbal book. The original Greek book was compiled in the first century AD by Dioscorides from Anazarbus in Cilicia. For his collections he travelled to the Greek mainland, Crete, Egypt and Petra, but he describes plants from much farther afield. In his preface to his five-volume work on the drugs employed in medicine, Dioscorides describes himself as leading 'a soldier-like life'. This statement has led later writers to conclude, probably falsely, that he was once a physician in the Roman army. Dioscorides' method was to observe plants in their native habitats, and to research previous authorities on these subjects. His information about dill and other simple drugs aims at medical precision, and his account is relatively free of supernatural and superstitious elements. In all he lists approximately 700 plants and slightly more than 1,000 drugs. He was a keen, objective observer of the science of drugs, and his medical judgements were respected until well into the Renaissance. This translation includes several Arabic advances in herbal science. The illuminations and text indicate that Dioscorides' original text was also accompanied by illustrations.

These are two pages from a Leonardo notebook, collected after his death from his loose papers and notes. The first section was begun at Florence on 22 March 1508, but the remainder comes from different periods in Leonardo's life (1452–1519). The notes are written in Italian, and in Leonardo's private mirror writing, left-handed, and moving from right to left. They contain short treatises, notes and drawings on a variety of the subjects that excited the scientific and artistic polymath, from mechanics (illustrated here) to the flight of birds. This manuscript was acquired by Thomas Howard, Earl of Arundel (1586–1646), the greatest English art collector of his or any age. Leonardo, the archetypal Renaissance hero, was the last man who could plausibly claim to know everything. His notes have appropriately come to rest at the home of human knowledge in the British Library.

ANDREÆ VESALII.

AN. ÆT. XXVIII

42
Andreas Vesalius, Pioneer of Anatomy
De Humani Corporis Fabrica, 1534
C.54.k.12, f. 1

These are the earliest scientific depictions of what goes on under the skin, inside the human body. They are the work of Andreas Vesalius, the Belgian anatomist, who was one of the first dissectors of human cadavers. Before Vesalius, physicians followed the teaching of Galen of Pergamum, the Greek physician who lived between AD 129 and perhaps 216. Galen dissected other animals, not humans. For a thousand years after Galen's death no original anatomical inquiries were performed, mainly because the Church was against the dissection

of human bodies. As a student, Vesalius was so fascinated by human anatomy that he stole the body of an executed criminal from the scaffold, and took it home to study. His greatest work, *De Humani Corporis Fabrica* (On the Structure of the Human Body) was published in 1534 at Padua University, where he was Professor of Surgery. With its detailed illustrations and descriptions, it set a new level of accuracy and clarity in anatomy, unveiling many structures that Vesalius had discovered for the first time. This page shows Vesalius himself holding a human arm.

43 >>
Chinese Terrestrial Globe, 1623
Maps G35

This is the earliest known Chinese terrestrial globe. It was created in Beijing in 1623 by the Jesuit Fathers Manuel Dias the Younger and Nicolò Longobardi, with the help of scholarly Chinese friends. Their inscription in Chinese states: 'We have made a model in the shape of a spherical ball… So we can deduce the origin of heaven and earth in the King of Creation. How respectfully we should apply ourselves to this study.' The globe is painted in lacquer on wood and is 59cm in diameter. It is held between two rings: one horizontal made of wood, and one bronze meridian, on which are marked the 360 degrees. It was commissioned by (or made as a present for) the Chinese Emperor, and comes from the Imperial Palace, Beijing. The globe is decorated with accurate markers of physical geography, information drawn from astronomy, and pictures of ships sailing along navigation routes past chimerical sea creatures. It symbolises the momentous encounter between the great civilisations of Renaissance Europe and age-old China. The map is drawn on a scale of 1:21 million and this hemisphere shows Africa, Europe, South America and the Atlantic. The globe is painted in lacquer on wood and is signed, using their Chinese names, by Dias (Yang Manuo) and Longobardi (Long Huamin). The globe was effectively a masterclass in selling European geographical theories to the Chinese, with many of the inscriptions written in terms that Chinese scholars would understand. Such influence was mutual. For example, one inscription refers to terrestrial magnetism, a phenomenon already acknowledged in China 40 years before Newton observed it.

44
Cassini's Map of the Moon
Maps K. Top 1.88

This is the first scientific map of the moon. It was made in Paris in about 1679 by the astronomer Giovanni Domenico Cassini (1625–1712). He became the first director of the new Paris Observatory, where he made a host of observations of the moon, Mars, Jupiter and Saturn, and discovered the division of Saturn's rings which still bears his name. Mapping the moon was one of his great achievements. Working in the 1670s, Cassini used a telescope to make careful observations of the moon's pock-marked surface. Thanks to his map, European scientists in the seventeenth century knew more about the moon than they did about much of the surface of the earth. If you look closely, you will find a moon maiden hiding behind one of the craters. Either Cassini or his engraver Claude Mellan included the joke, believing that this tiny part of the surface looked like a beautiful woman.

Down Bromley SE
Tuesday

My dear Wallace

After I had despatched my last note, the simple explanation which you give had occurred to me, & seems satisfactory.

I do not think you understand what I mean by the non-blending of certain varieties. It does not refer to fertility; an instance will explain: I crossed the Painted Lady & Purple sweet-peas, which are very differently coloured vars, & got, even out of the same pod, both varieties perfect but none intermediate. Something of this kind, I think, must occur at first with your butterflies & the 3 forms of Lythrum; tho these cases are in appearance so wonderful, I do not know that they are really more so than every female in the world producing distinct male & female offspring.

I am heartily glad that you mean to go on preparing your journal.

Believe me yours very sincerely

Ch. Darwin

45

Charles Darwin on an Experiment

Letter to Alfred Russel Wallace, 1859
Add. MS 46434, f. 64 and ff. 64v–65

Although he was not the only originator of the theory of evolution of which he has become the eponym, Darwin was the first thinker to gain wide acceptance for the concept among biological experts. By adding his own specific idea of natural selection to the crude evolutionism of his grandfather (Erasmus Darwin) and others, Darwin supplied a sufficient cause to the idea. So he raised it at once from a hypothesis to a verifiable theory. Darwin's theory of human evolution was published long before genes had been discovered. His letter of 1866 to a fellow naturalist, Alfred Wallace, shows that Darwin was already doing research into heredity that anticipated the genetic discoveries of the next century. All of us have one female and one male parent, yet each of us is either male or female, not an intermediate hermaphrodite. This letter describing the early flowering of genetics was found by chance in a volume of correspondence in the British Library.

46

Patent for the Windsurfer, 1968

Hoyle Schweitzer and James Drake
Filed 27 March 1968 and published as US 3487800 and GB 1258317 (28 February 1969)
Patent 1258317, f. 4

The British Library is the final home of the Patent Office Library. This comprises a historic record of inventions and gadgets on every topic under the sun and over the moon. This patent for a sailboard was registered in 1968 by a businessman who enjoyed surfing and an aeronautical designer from California. Where else? An articulated mast is attached by a universal joint to the board, while a boom running horizontally is used to give direction. The boom also enables the surfer to hang on. No rudder is needed. Originally fibreglass was used for the board, but the cheaper and longer-lasting polyethylene was used later. This patent was evidence in several cases of litigation by inventors claiming that they had had the idea of a sailboard earlier. The windsurfers won.

1,258,317
1 SHEET

COMPLETE SPECIFICATION

This drawing is a reproduction of the Original on a reduced scale.

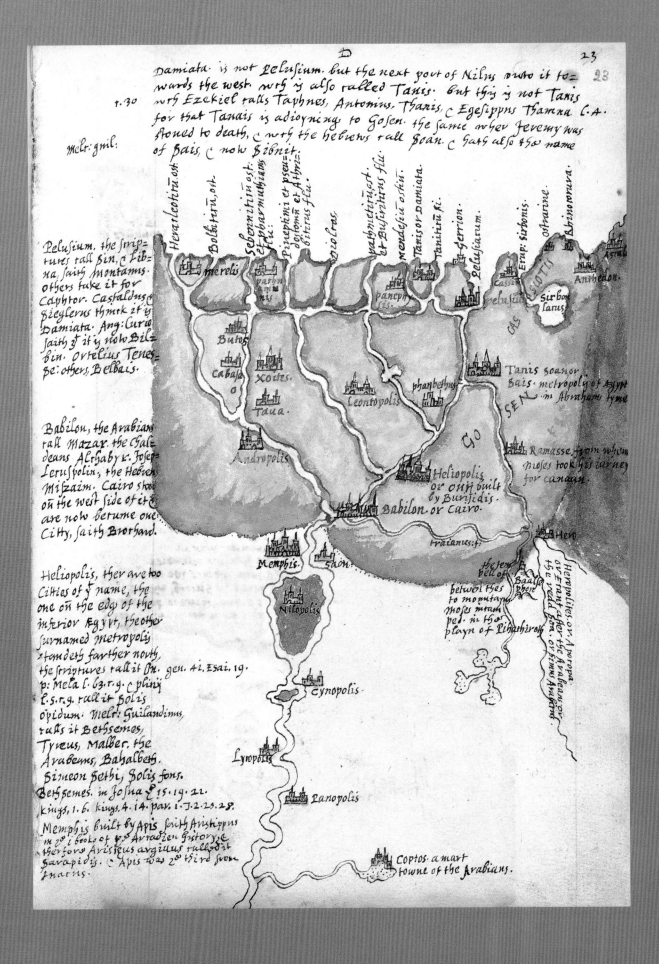

Damiata. is not Pelusium. but the next port of Nilus vnto it to=
wards the west. wch is also called Tanis. but this is not Tanis
wch Ezekiel calls Taphnes, Antonins. Thanis, Egesippus Thamna. C.A.
for that Tanais is adioyning to Gosen. the same wher Ieremy was
stoned to death, & wch the hebrews call Soan. & hath also the name
of Bais, & now Sibnit.

t. 30

Melr: gmil:

Pelusium. the scrip-
tures call Sin, & Libi-
na, saith Montanns.
others take it for
Caphtor. Castaldus &
Zieglerus thinck it is
Damiata. Ang: Curio
saith it is now Bil-
bin. Ortelius Tenes-
se: others, Belbais.

Babilon, the Arabians
call Mazar. the Chal-
deans AlShaby k. Josep:
Ieruspolin, the Hebrews
Mizraim. Cairo stood
on the west side of it &
are now become one
Citty, saith Brorhand.

Heliopolis, ther are too
Cities of y name, the
one on the edg of the
inferior Egypt, the other
surnamed metropoli
standeth farther north,
the scriptures call it Sin. gen. 41. Esai. 19.
p: Mela l. 63. r. 9. & plini
l. 5. r. 9. call it Solis
opidum. Melr: Guilandinus,
calls it Bethsemes,
Tyreus, Malber. the
Arabeans, Bahalbeth.
Simeon Sethi, Solis fons.
Bethsemes. in Josua y 15. 19. 22.
kings, 1. 6. kings. 4. 14. par. 1. J. 2. 23. 28.

Memphis built by Apis saith Aristippus
in 2° & books of y Arrabien historye &
therfore Aristeus argitus called it
Sarapidis. & Apis was y third from
Inarns.

Heracleortra. ost.
Bolbitin. ost.
Sebenitin ost. et Pharmuthiacus
Pinephmi et pseu=
dostomi et Athri=
bitirus flu.
ziolros
Pathmetinost.
et Busiritirus flu.
Mendesiu ostiu.
Tanisor-Damiata.
Tanitirū fi.
Gerrion
Pelusiarum.
Erup: sirbonis.
ostraine
arnaonizine

merelis
pashi
tanis
pancpty sis.
Cassiu
pelusia
Astra
Anthedon
sirbo-
lianus

CAS
SIOTU

Butos
Cabasa o
Xoites
Taua.

Andropolis

Leontopolis

phanbethus

Tanis soa nor
bais. metropoly of Egypt
in Abrahams tyme

SEN

GO

Ramasse. from whene
moses took his iurney
for canaan.

Heliopolis
or on built
by Bunsidis.
Babilon. or Cairo.

traianus: f.

Hero

Memphis.
saou

Nilopolis

betwen thes
to mountains
moses marh
ped. in the
playn of Pihathiroth

the red
sell of
BaalSe
phon

Heriopolis. or Aporopa:
or Frank after the Arabeans. or
the red sea. or situs Arabicus

Cynopolis

Lynopolis

Panopolis

Coptos. a mart
towne of the Arabians.

06 Monarchy

47
**Sir Walter Raleigh's Notes
for his History of the World**
Add. MS 57555, f. 23

Raleigh, or Ralegh (1552–1618), made these notes while he was a prisoner in the Tower of London. They describe and illustrate the delta of the Nile and the history of the Pharaohs. The first and only volume of his history reaches the second Roman war with Macedonia. The soldier, seaman, explorer, pirate, poet and upwardly mobile courtier was also a scholar. Although he took little part in the dark intrigues at the end of Elizabeth's reign, he was arrested in 1603, and held in the Tower until 1616, when he was released to make an expedition to the Orinoco in search of a goldmine. But the mission was a failure. Raleigh lost his fleet and his son, and broke his terms by razing a Spanish town. On his return in 1616, the Spanish Minister in London invoked the superseded death sentence, and Raleigh was beheaded at Whitehall.

In the modern world monarchs are a threatened species. But for most of history and over most of the world, kings (or their local equivalents) were the masters. Until recently kings and queens were the scaffolding for our schoolchildren's history lessons. They learnt the rhyming mnemonic: 'Willy, Willy, Harry, Ste…' – the names of the English kings from William the Conqueror. British history can be interpreted as a long march from absolute monarchy through civil wars, aristocracy and anarchy to representative democracy.

Not many monarchs were authors, with the exception of Queen Victoria; or intellectuals, with the exception of Queen Elizabeth I. George III (or his brother, the Duke of Gloucester) catching Edward Gibbon in the royal library, joked: 'Another damned, thick, square book! Always scribble, scribble, scribble! Eh! Mr Gibbon?' They may not have written them, but kings owned the books and made the libraries. Kings are founding fathers of the British Library. The King's Library Tower, spectacular centrepiece to the Library, houses the collection of George III, given to the nation by George IV. And monarchy was associated with most of the memorable events in the history of the United Kingdom, from the Norman Conquest to the torrent of grief at the death of Diana, Princess of Wales.

You cannot reach far in the caverns of the Library without meeting a monarch, for good or ill. So, for example, here is a fulsome letter from the Nawab of Arcot to George III, asking in the nicest possible way for his continued support. And here is Elizabeth I reluctantly addressing her future successor on the rights and duties of a monarch. Walter Raleigh writes a love poem to one monarch, and scribbles a history of the pharaohs while waiting for execution at the orders of another monarch. Charles d'Orléans, a French royal, writes courtly poems while he is a prisoner in the Tower. They are illustrated on a miniature for the English King, Edward IV. Here is the prayer-book that the English Queen with the shortest reign (nine days) carried on her way to execution at the Tower. There is a drawing of three stages of the execution of Mary Queen of Scots, which set an unfortunate precedent for monarchy. Kings and queens have left their bloody and notorious, happy and glorious fingerprints all over the Library.

Sir Thomas More's Last Letter to Henry VIII
Cotton Cleopatra E vi, ff. 176v–77

On the fall of Cardinal Wolsey in 1529, Thomas More, against his strongest wish, was appointed Lord Chancellor. He sympathised with John Colet and Erasmus in their desire for a more national theology and for radical reform in the manners of the clergy, but like them he felt no promptings to break with the historic Church. He watched with displeasure the successive steps that led to the final schism from Rome. In 1532 he resigned the chancellorship. In 1534 Henry was declared head of the English Church and More's steadfast refusal to recognise any other head of the Church than the pope led to his harsh imprisonment in the Tower for over a year. In this last letter to his King, he writes: 'I am your trew bedeman now and ever have bene and will be till I dye, how so ever your pleasure be to do by me.' But for refusing to recant, he was beheaded. More is one of the most eminent humanists and writers of the Renaissance. In league tables of the popularity of monarchs, for what they are worth (not a lot), Britons today vote Henry VIII the most popular king.

50 >>
Lady Jane Grey's Prayer Book
Harley MS 2342, ff. 74v–75

Lady Jane Grey carried this tiny prayer book to the scaffold at her execution in 1554. The fifteen-year-old girl was the great-granddaughter of Henry VII. On the death of her half-brother, Edward VI, in 1553, she had been made to accept the English throne in order to prevent the accession of the Roman Catholic Mary. After only nine days she was forced to abdicate in favour of Mary. She wrote farewell messages in her prayer book, which she handed to Sir John Bridges, lieutenant of the Tower of London, just before the axe fell. The note in her hand at the foot of the pages is addressed to her ambitious father, the Duke of Suffolk.

48
Courtly Poetry in the Tower
Manuscript of poems by Charles d'Orléans
Royal MS 16 F.ii, f. 73

Charles, Duke of Orléans was captured at Agincourt in 1415, and held a prisoner in the Tower of London for the next 25 years. While there, he composed courtly poetry in French and English. It is conventional, lyrical and graceful. This miniature, illustrating a manuscript of his poems, was painted for King Edward IV. It shows Charles in three different poses in the White Tower, with Old London Bridge visible in the background.

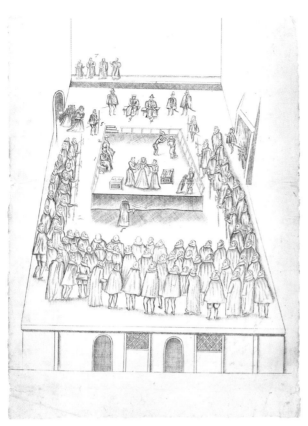

51
**The Execution
of Mary Queen of Scots, 1587**
Add. MS 48027, f. 650

This contemporary drawing shows Mary
at three stages of her execution. Mary,
a Roman Catholic with a claim to the
English throne, was a focus for discontent
and plots under Elizabeth I. After almost
twenty years in custody in England, she
was brought to trial in 1586 for complicity
in the Babington conspiracy. In spite of
Elizabeth's procrastination, Mary was
executed in the hall of Fotheringay Castle,
Leicestershire. Robert Beale, the clerk
of the Privy Council, carried the death
warrant to Fotheringay and read it aloud
before the execution. This drawing was
found in his papers. It shows Mary
entering the hall attended by her women,
on the scaffold, and lying on the block.
It does not show her little dog, which,
according to the Dean of Peterborough
(numbered '6' in the foreground), had
crept under her skirts and after the
execution could be removed only by force.

52
**Sir Walter Raleigh's Notes
for his History of the World**
Add. MS 57555, f. 172v

Raleigh's notebook (see also fig. 47)
contains this autograph fair copy of a
poem addressed to the Queen under the
pseudonym 'Cynthia' (f. 172v). It's true
that he introduced tobacco and potatoes
to Britain, but the story of his laying his
plush cloak over a puddle at Greenwich
in order to protect the Queen from
wetting her feet is, alas, probably legend.
When he was eclipsed as Elizabeth's
favourite in 1587 by her new toyboy, the
young second Earl of Essex, Raleigh
went to Ireland, and planted his estates
in Munster with settlers. He became a
close friend of the poet Edmund Spenser.
On his return to England, he was
committed to the Tower for a secret
affair with Bessy Throckmorton, one
of the queen's maids of honour. For more
than four years, he was excluded from
'Cynthia's' presence. He and Bessy
later married.

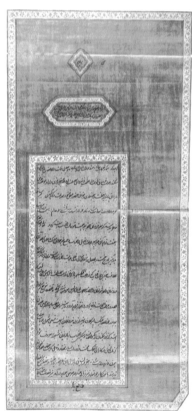

53
Letter from Elizabeth I to her Successor, 1603
Add. MS 18738, f. 40v

A letter from Queen Elizabeth I to the future King James I, signed 'your Loving and frendely [sic] sister Elizabeth R. January 1603'. Love and friendship were not the salient features of Elizabeth's relationship with her heir. She was suspicious of his mother (Mary Queen of Scots), whose execution she had tolerated. She was wary of Scotland's pretensions and religious factionalism. But, at the end, she recognised that the monarchical show must go on.

54
Letter from the Nawab of Arcot to George III, 1764
IOR H/97, pp.356–57

After the breakdown of centralised Mughal authority in the eighteenth century, autonomous regions developed in India, and European and Indian politics became intertwined. Britain and France backed rival Indian princes. In this illuminated letter in Persian of 15 April 1764, Muhammad Ali Khan Walajah, Nawab of Arcot, congratulates King George III on the restoration of peace in Europe after the Seven Years' War (1756–1763). He thanks him for English support to consolidate his authority in Arcot. He concludes with a request that such support continue for both himself and his son and heir.

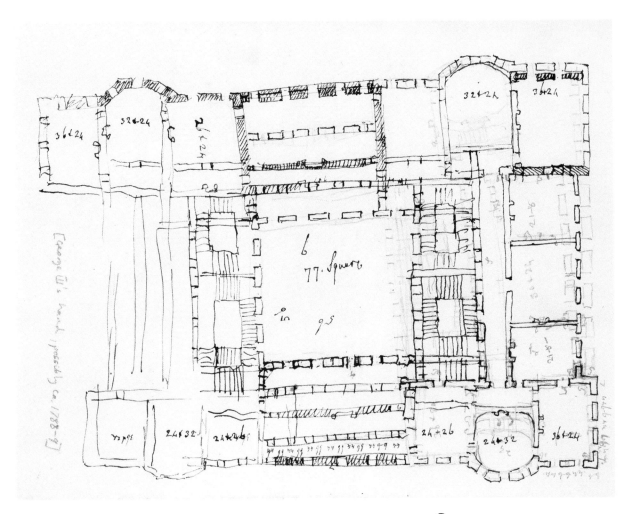

55
A King's Design for a Palace
Drawing by George III, c.1788–89
Maps 7 Tab 17

This is the only known plan for a palace
drawn by a British monarch. George III
(1738–1820) drew it during an attack
of mental derangement in 1788–89.
His ailment is now believed to have been
caused by porphyria. This disturbing
plan of Ludwigian fairy-tale grandeur
shows no fewer than four grand staircases
leading from a central courtyard. A series
of corridors instead of an enfilade of
rooms occupies the wings. Was George
imagining himself playing hide-and-
seek with his minders down endless
corridors? He left his virtual plan in a
volume of manuscript plans of the real
Hanoverian palaces when he was con-
templating a trip to Hanover following
his recovery.

56 >>
Royal Malay Letter to Napoleon III
Illuminated letter in Malay, 1857
Or.16126

This royal Malay letter from the ruler
of Johor, Temenggung Daing Ibrahim,
to the Emperor of France is a triumph of
style over substance. It is dated Monday
17 Syaaban AH 1273 (Sunday 12 April
1857). Its thirteen golden lines pay effusive
compliments to Napoleon III, but little
else. By the middle of the nineteenth
century, French interests in Southeast Asia
were focussed on Indochina, while Johor's
allegiance was firmly with the British. In
the letter Temenggung makes no requests
of the French, but adroitly voices his
greatest praise for the Emperor in terms of
the French strategic alliance with Britain,
'both sides thereby gaining in such
strength that no other nation can match
them, as long as the sun and moon revolve'.

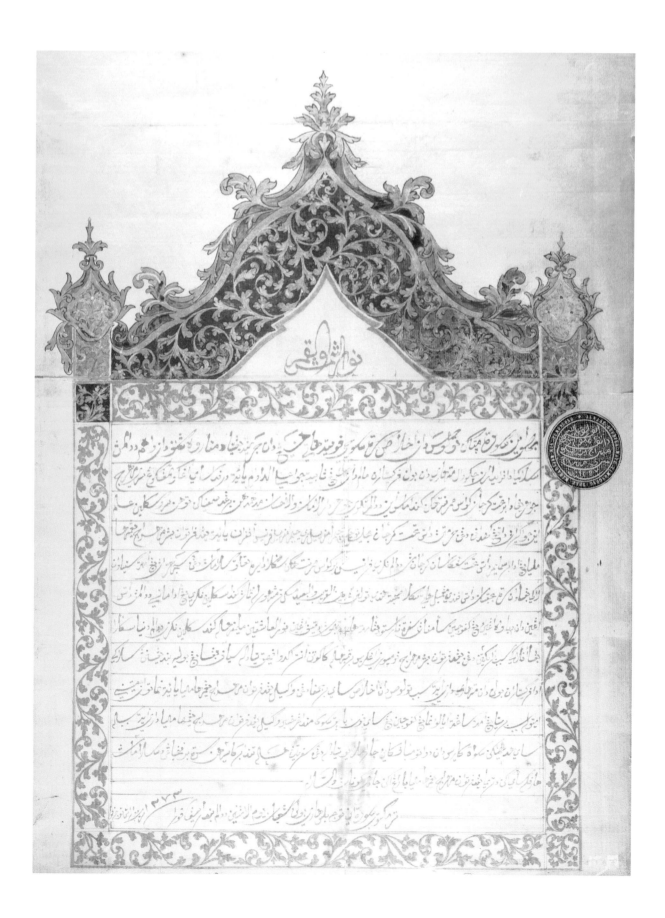

who had lately been kill'd, these lying on the beach
the heart was stuck on a forked stick which was fixed
to the head of one of the largest canoes, the gentlemen brought
the head on board with them. some of the flesh was broiled and eat by
some of the officers & most of the crew.
but soon after returned on board, and was informed of the above
circumstances, and found the quarter deck crowded with
the natives and the mangled head or rather part of it for the
under jaw and lips were wanting lying on the Tafferel the scull
had been broke on the left side just above the temples, the
remains of the face had all the appearances of a youth
under twenty. A piece of the flesh had been broiled and
eat by the natives before all the officers and most of the crew.
The sight of the head and the relating the above circumstances
struck me with horror and filled my mind with indignation
against these Canibals, curiosity however got the better of my indig-
nation especially when I considered it would avail but little,
and being desireous of becoming an eye witness to a fact which
many had their doubts about I ordered a piece of the flesh
to be broiled and brought on the quarter deck where one of
the Canibals eat it with a surprizing avidity. This

[several heavily crossed-out lines]

the flesh, and refused to accept or even to touch the knife with
which it was cut. Such was this islanders indignation against
this vile custom and worthy of imitation by every rational
being —

9.

07 New Worlds

57
Captain Cook's Journal, 1775
Add. MS 27888, f. 150

A horrid experiment with cannibals. A freshly killed body has been found on the beach. A midshipman brings a mutilated head on board. The quarter-deck is crowded with natives. 'The sight of the head and the relating of the above circumstances struck me with horror and filled my mind with indignation against the Canibals [sic]; curiosity however got the better of my indignation.' Captain Cook wants to see for himself something which many had their doubts about. He orders a piece of the flesh to be broiled and brought on the quarter-deck, 'where one of the Canibals [sic] eat it with surprising avidity'. This comes from Cook's second voyage of discovery in the *Resolution* and *Adventure* (1772–75). His mission was to discover how far the lands of the Antarctic stretched northwards. So he sailed round the edge of the ice, reaching 71 degrees 10 minutes south in latitude, 110 degrees 54 minutes west. During the intervals between the Antarctic voyages, he visited Tahiti and the New Hebrides, and discovered New Caledonia and other groups. Owing to his precautions, there was only one death among his crews during all the three years. Cook did more than any other navigator to add to our knowledge of the Pacific and the Southern Ocean, including the possibility of cannibalism.

Islanders between the 'devil' of continental Europe and the deep blue sea were naturally centrifugal. The earliest inhabitants of the British Isles arrived from the south and the east. And the Romans, Anglo-Saxons, Vikings, Normans, Jews, East and West Indians, and all those who followed them, also came in search of new worlds. Ideas have boats as well as legs. The modern British are those who missed the boat when the Mayflower sailed. Today the traffic in ideas also has a contraflow eastwards across the Atlantic. But it is natural that the British Library should possess a rich store of material from our descendants and ancestors across the Atlantic. And natural that the unique vein in it comes from those days of discovery, when merchant venturers and buccaneers discovered a world that was new to them.

So, for example, there is the first *portolano* (chart for mariners) of the hitherto unknown west coast of South America. This priceless strategic and commercial document came into British hands in an appropriately piratical way. The Spanish captain who owned the charts chucked them overboard when his ship, the *Rosario*, was captured by an English merchant venturing on the windy side of the law. The English recovered his maps, and returned them to London. There they were copied. They opened the gateway for the British to the *terra nova* of South America. Here too is the foundation map of the United States, during the prolonged negotiations after the American War of Independence. The final version was much more favourable to the British and Canadians, so successive British governments kept this map secret until 1896. In an early print of the Old World's take on the New, here comes Columbus, distributing gifts and God to the American natives. Meanwhile Captain Cook writes up his gruesome experiment with cannibalism in the South Seas. And the *Daily Mirror* shouts the landing of Man on the Moon.

Dante put Ulysses in Hell for his presumption in seeking new worlds beyond God's plan for man. By Dante's standards the keepers of the British Library have a chilling future waiting for them.

<< 58

A Spanish Spin
on South American Geography
Map of South America by Diego Homem,
1555, from the Queen Mary Atlas, showing
upper Amazon River
Add. 5415A, ff. 23v–24

This world map was drawn and illustrated
by the leading Portuguese cartographer,
Diego Homem, in 1555. Diego was
charged with murder, and fled for his
life to England. There he was welcomed
with open arms, as the best cartographer
from the land of map-makers. His map
of South America, part of the Queen
Mary Atlas which he prepared for the
English Queen and her husband, King
Philip II of Spain, gives a Spanish spin
to geography. It depicts Francisco Pizarro

(1475–1541) crushing the Incas,
cannibalism (copied from a German
woodcut), the cutting of giant redwoods
for export, birds of paradise, silver-
mining, and the giants of Patagonia.
When Mary I died, Queen Elizabeth
inherited the atlas. In March 1559 she
scratched out the Spanish arms on the
crest. Perhaps she resented Spanish
territorial ambitions. Perhaps she was a
woman scorned. She had just been jilted
by Philip II, admittedly to her great relief.

59

The Duke's Plan of New York
Anonymous (after Jacques Cortelyou), 1664
K.Top.121, f. 35

The greatest city and largest port in the
USA grew from Mannados (or New
Amsterdam), the trading post established
by Henry Hudson in 1609. This map
was drawn in 1664, the year that Britain
captured New Amsterdam from the
Dutch colonists and renamed it in honour
of the Duke of York, the future James II
(reigned 1685–88). It was based on a
map drawn in September 1661. Note the
triumphalist red crosses of St George flags
on the warships in the East River, where
today Brooklyn Bridge links Manhattan to
the mainland. You can see the origins of
Wall Street in the city wall to the left, and
Battery Park in the fortification to the
right. Great oaks from little acorns grow.

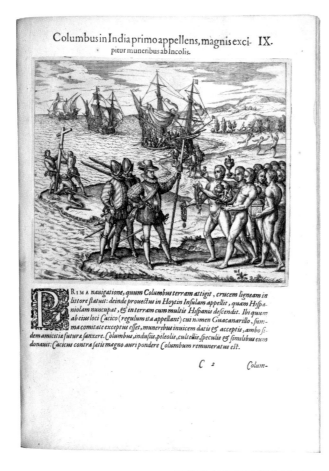

Columbus in India primo appellens, magnis exci- IX.
pitur muneribus ab Incolis.

RIMA navigatione, quum Columbus terram attigit, crucem ligneam in littore statuit: deinde profectus in Hoytin Insulam appellit, quam Hispaniolam nuncupat, & in terram cum multis Hispanis descendit. Ibi quum ab eius loci Cacico (regulum ita appellant) cui nomen Guacanarillo, summa comitate exceptus esset, muneribus inuicem datis & acceptis, ambo sidem amicitiæ futuræ sanxere. Columbus, indusiis, pileolis, cultellis, speculis & similibus eum donauit: Cacicus contra satis magno auri pondere Columbum remuneratus est.

C 2 Colum-

60
Christopher Columbus meeting Native Americans
Americae pars quarta (Volume IV of *Grands Voyages*) by Theodore de Bry
Frankfurt, 1594
G.6628, plate IX

The Old World meets the New. This is an Old World eye's view of that meeting. Naked Native Americans are holding gifts which Christopher Columbus has just presented to them. In the background, more ships arrive. Other Europeans erect a cross. In his letter of 1493, Columbus gave his own take on this meeting (in Spanish): 'All Christendom ought to feel joyful and make great celebrations and give solemn thanks to the Holy Trinity with many solemn prayers for the great exaltation which it will have, in the turning of so many people to our holy faith, and afterwards for material benefits, since not only Spain but all Christians will hence have refreshment and profit.'

61
Chart of the West Coast of South America
Copied by William Hack from original 1698
Maps 7 Tab 122

Maps give knowledge. Knowledge gives power. This is the first detailed map of the Pacific coast of Central and Southern America. It includes facts essential for navigation that were previously unknown to the English. It was in a folio of maps on the Spanish ship *Rosario*, which was captured by English privateers in 1680. There were charts for individual ports that enabled the sailing ships to avoid the shallows and rocks as they made their way in. The captain threw his maps into the sea in order to prevent them falling into the hands of the enemy. But the English managed to recover his maps, and to return them to London. They gave the Admiralty power to unlock a door to a new quarter of the world.

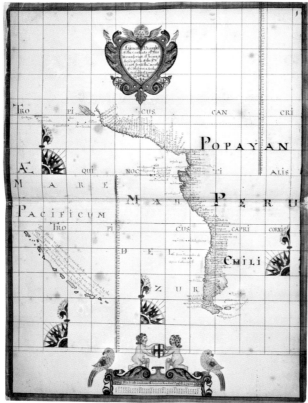

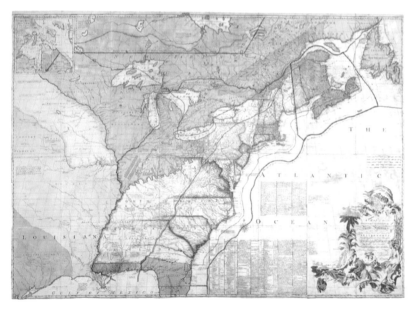

62

The Red-Lined Map 1782
Maps K. Top. 118.49.b

This map by John Mitchell (1711–1768) was used during the negotiations of the Treaty of Paris, which recognised the independence of the United States of America at the end of the American War of Independence (1776–83). The red lines illustrate interpretations of the clauses of various treaties. The final treaty line of 1783 was much more favourable to the British. Fear of revealing the earlier lines and being compelled to surrender large tracts of Canadian land to the United States led successive British governments to keep the map secret until 1896. So this most crucial foundation document of American history was unknown in the United States until the twentieth century.

63

Wagon Park, Brandy Station
Photograph by Timothy H. O'Sullivan, 1863
C.3009-02

The American Civil War was the first war to be comprehensively recorded by photography, at any rate from the Union side. This 1863 photograph of massed wagons at Brandy Station, on a branch of the Rappahannock River in Virginia, shows how it was also the first war to be fought with logistics and industrial might as well as swords and guns. Capturing or destroying the enemy's wagons, supplies and ammunition was as important as winning on the set-piece battlefield. This picture was one of at least 8,000 taken by the large squad of photographers hired by Matthew Brady to cover the war. Technology was insufficiently advanced for them to record scenes of fast-moving battle. But their images of battlefield carnage shocked the *New York Times* into commenting, 'Mr Brady has done something to bring home to us the terrible reality and earnestness of war.'

64
Cheyenne Sun Dance Pledgers
Photograph by Edward S. Curtis, 1911
LR.298a.23, vol. XII, opp. 136

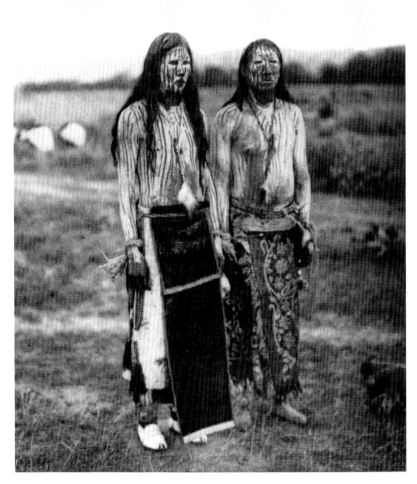

This photograph of two aboriginal Americans was taken by Edward Sheriff Curtis. He devoted his career from 1896 to recording the North American peoples and their way of life, which was to vanish almost completely during the 35 years of his study. With financial assistance from J. Pierpont Morgan, he published the first of twenty historic volumes in 1907, combining evocative and detailed photographs with equally informative text. In all, he took some 40,000 negatives. Earlier US photographers had portrayed the Native Americans as ferocious warriors. Curtis stressed their peaceful arts and culture, perhaps in idealised terms. His gallery depicts, describes and preserves for posterity the Amerindians of the United States and Alaska.

65 >>
Captain Scott's Last Diary Entry
Add. MS 51035, f. 39

Shown here is the final entry in the diary of Robert Falcon Scott, explorer, adventurer and popular hero. Its date must be 27 March 1912, or thereabouts. That is the day on which Captain Scott and the remainder of his party died in his tent near One Ton Depot. They had reached the South Pole in January, only to discover that Roald Amundsen, the Norwegian, and his expedition had beaten them to it by a month. Their return had then been delayed by sickness, insufficient food, and atrocious weather. Edgar Evans and Lawrence Oates had already died, the latter sacrificing himself with the last words: 'I am just going outside and may be some time.' Scott's final diary entry ends with the words, 'For God's sake look after our people,' an echo of Charles II's last utterance, 'Let not poor Nelly starve.' Captain Scott is a heroic exemplar of true English grit. However, revisionist history now accuses him of sentimental folly, for instance in refusing either to take dog sleighs or to use the dogs for food on the way back.

we shall stick it out
to the end but we
are getting weaker of
course and the end
cannot be far
It seems a pity, but
I do not think I can
write more —
R. Scott

Last Entry —
For God's Sake look
after our people

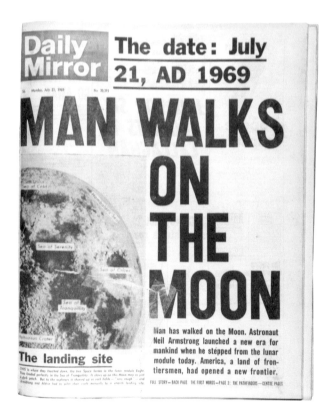

66

Man Walks on the Moon
Daily Mirror, 21 July 1969, p. 1

The splash made in the *Mirror* by the
first man on the Moon. Neil Alden
Armstrong was the commander of
Apollo 11. He blasted off with Buzz
Aldrin and Michael Collins on a Moon-
landing expedition. As the craft touched
down on 20 July 1969, Armstrong
radioed: 'Houston. Tranquillity Base
here. The Eagle has landed.' It was
after midnight, Greenwich Mean Time
(hence the *Mirror*'s date of 21 July) when
Armstrong and Aldrin became, in that
order, the first men to set foot on the
Moon, Collins remaining in orbit in the
Command Module. As he stepped on the
Moon, Armstrong delivered his rehearsed
line: 'That's one small step for a man, one
giant leap for mankind.' Armstrong came
back to publish *First on the Moon* in 1970,
and to teach aerospace engineering at
Cincinnati University.

I wander thro' each dirty street
Near where the dirty Thames does flow
And ~~see~~ mark in every face I meet
Marks of weakness marks of woe

In every cry of every man
~~In every infants cry of fear~~
~~In every voice of every child~~
In every voice in every ban
The ~~german~~ mind forg'd ~~manacles~~ I hear

~~How~~ the chimney sweepers cry
~~Blackens o'er the churches walls~~ Every blackning church appalls
And the hapless soldiers sigh
Runs in blood down palace walls

But most the midnight harlots curse
~~I slept~~ in the dark From every dismal street I hear
In the silent night Weary around the marriage hearse
I murmured my fears And blasts the new born infants tear
And I felt delight But most ~~thro~~ ~~every~~ street I hear
 How the midnight harlots curse
In the morning I went Blasts the new born infants tear
As rosy as morn And hangs with plagues the marriage hearse
To seek for new joy But most the shrieks of youth
But I met with scorn But most thro midnight
 To Nobodaddy How the youthful
~~Why art thou silent & invisible~~
Father ~~of jealousy~~
Why dost thou hide thyself in clouds
From every searching eye

Why darkness & obscurity
In all thy words & laws
That none dare eat the fruit but from
The wily serpents jaws
Or is it because ~~secrecy~~ ~~gains~~ females ~~loud~~ applause

The ~~modest~~ rose puts forth a thorn
The ~~humble~~ ~~coward~~ sheep a threatning horn
While the lilly white shall in love delight
~~And the lion increase freedom & peace~~ 4

The priest loves war & the soldier peace
Nor a thorn nor a threat stain her beauty bright

When the voices of children are heard on the green
And whisprings are in the dale
The days of youth rise fresh in my mind
My face turns green & pale

Then come home my children the sun is gone down
And the dews of night arise
Your spring & your day are wasted in play
And your winter & night in disguise

Are not the joys of morning sweeter
Than the joys of night
And are the vigorous joys of youth
Ashamed of the light

Let age & sickness silent rob
The vineyards in the night
But those who burn with vigorous youth
Pluck fruits before the light

The Tyger

Tyger Tyger burning bright
In the forests of the night
What immortal hand or eye
~~Dare~~ frame thy fearful symmetry

Burnt in
~~distant~~ distant deeps or skies
~~The cruel~~ ~~fire~~ ~~of thine eyes~~
On what wings dare he aspire
What the hand dare seize the fire

And what shoulder & what art
Could twist the sinews of thy heart
And when thy heart began to beat
What dread hand & what dread feet

~~Could fetch it from the furnace deep~~
~~And in thy horrid ribs dare steep~~
~~In the well of sanguine woe~~
~~In what clay & what mould~~
~~Were thy eyes of fury rolld~~
~~Where~~ the hammer ~~where~~ the chain
In what furnace was thy brain
What the anvil what ~~dread~~ grasp
~~Could~~ its deadly terrors ~~clasp~~ clasp

Tyger Tyger burning bright
In the forests of the night
What immortal hand & eye
Dare ~~frame~~ thy fearful symmetry

08 Literature

67

Marks of Weakness, Marks of Woe
William Blake's notebook, containing
drafts of poems including 'London' and
'The Tyger', 1794 or earlier
Add. MS 49460, f. 5

Observe our mystical poet fine-tuning
his work, still recited by every (well,
almost every) schoolchild in Britain.
In 'The Tyger', what immortal hand
or eye 'dare' or 'could' frame thy fearful
symmetry? You can just make out bits of a
lost stanza. Blake was a natural visionary
and genius. He was born in 1757, the son
of an Irish hosier. He did not go to school,
but was apprenticed to an engraver. Blake
became an engraver and painter, as well
as a poet. After studying at the Royal
Academy School, he began to produce
watercolour figure subjects and to engrave
illustrations for magazines. His first book
of poems, *Poetical Sketches*, appeared in
1783. His lyrics express his ardent belief
in the freedom of the imagination, and
his hatred of rationalism and materialism.
In all his work he was inspired by his
most real and vivid faith in the unseen.
He believed that he was guided and
encouraged by perpetual visitations from
the spiritual world.

'A truth that's told with bad intent
Beats all the lies you can invent
It is right it should be so
Man was made for joy and woe
And when this we rightly know
Thro' the world we safely go
Joy and woe are woven fine
A clothing for the soul divine.'
(from Blake's 'Auguries of Innocence')

Literature is the art at which the English excel, partly because of the
mongrel flexibility and vast vocabularies of the English languages.
Literature means books. And the books of the world can generally be
mustered *en masse* only in libraries. One copy of every book published
in the United Kingdom may be claimed by the British Library under the
Copyright Act. Full many a flower is published to blush unseen in the
vaults. But the Library also holds the elite literature from around the
world. So, of course, there are all the folios and texts of Shakespeare,
from which one can reconstruct the rapid but complex births of such
masterpieces of world literature as *Hamlet* and *King Lear*. Here too are
the works of the great critics who have tackled Shakespeare, piling
Dryden on Hazlitt, Samuel Johnson on Coleridge, and Bradley on (less
reverently) Bernard Shaw.

'Whan that Aprill with his shoures soote / The droghte of March hath
perced to the roote.' Chaucer's lines are here in many forms, but none so
beautiful as that illustrated by Edward Burne-Jones for the Kelmscott
Press. 'Newman Noggs scrambled in violent haste upstairs with the
steaming beverage…' – you can read in Dickens's own hand the words
of a master storyteller steaming onto the page, with scarcely a blot or
second thought. Meanwhile the game's afoot for Holmes, as originally
penned in stories that still attract mass cults from Tokyo to New York.

So from the dawn of literature in Old English, surviving in a tenth-
century manuscript, Beowulf fights Grendel, and Grendel's even more
frightening mother, and then the dragon, and becomes the archetype of
the hero with a stiff upper lip and loose lower jaw in ripping yarns, down
the centuries to James Bond. But also here is the Swahili Beowulf, 'the
lion of cities'. Kieu, the Vietnamese heroine, suffers for love, and is
eventually rewarded with a happy ending. Back at home Jane Eyre and
Anne Elliot find true love after travail. The greatest English historian
keeps his book list on a house of cards, and Wilfred Owen catches the
blood and tears of war. Alexander Pope's autograph draft of his Homer
translation is here. The British Library is a great lake in which Beowulf
can swim and heroines of forgotten romances can paddle.

HPÆT PE GARDE

na ingeaṛ dagum. þeod cyninga
þrym ge frunon huða æþelingaſ elle
fre medon. oft ſcyld ſcefing ſceaþe
þreatum moneguꝫ mægþum meodo ſetla
ofteah egſode eorl ſyððan æreſt pearð
fea ſceaft funden he þæſ frofre geba
peox under polcnum peorð myndum þah
oð þ him æghpylc þara ymb ſittendra
ofer hron rade hyran ſcolde gomban
gyldan þ pæſ god cyning. ðæm eafera pæſ
æfter cenned geong ingeardum þone god
ſende folce tofrofre fyren ðearfe on
geat þ hie ærdrugon aldor leaſe. lange
hpile him þæſ lif frea puldreſ pealdend
porold are forgeaf beopulf pæſ bremen
blæd pide ſprang ſcyldeſ eafera ſcede
landum in. Spa ſceal geong guma gode
ge pyrcean fromum feoh giftum on fæder

<< 68

Beowulf

Anonymous, place of production
unknown, first quarter
of the eleventh century
Cotton MS Vitellius A XV, f. 132

This is the unique text of the first work
of English literature: *Beowulf*. 'Listen.
We have heard of the spear-danes in
days of old, of the glory of the kings of
a people, how those princes performed
deeds of courage…' This tells how the
hero, Beowulf, fights and kills the monster
Grendel, and Grendel's mother, who
comes the next night to avenge her son.
Then, 50 years later, Beowulf fights
a dragon in which both are mortally
wounded. The legend relates to historical
events in the sixth century, but the poem
is generally dated to the eighth century, at a
time when England was being converted
from paganism to Christianity. This sole
manuscript was written on 116 folios
of vellum by two scribes probably very
early in the eleventh century. *Beowulf* is
much the most important poem in Old
English, and is the first major poem in a
European vernacular language.

69

Liyongo

Poem in Swahili by Sayyid Abdullah
bin Nassir, 1891
Scroll of thick paper. Text in red and
black ink, written in Arabic script
OR.4534

This poem, 'Takhmisi ya Fumo
Liyongo', eulogising the legendary
Swahili hero Liyongo, is written in
Swahili using Arabic script. It was
composed by Sayyid Abdullah bin
Nassir, and praises the power of Liyongo,
whose deeds inspired a number of other
poems. Liyongo, 'the lion of cities',
is said to have been a great warrior.
Employing superior strength and skill,
he evaded assassination by his enemies,
and was eventually killed only through
the treachery of his son. There is some
evidence that he may have lived in the
twelfth or thirteenth centuries.

70
Dante's Inferno
Edition published in Florence, 1481
G.10874

In Canto XIX of the *Inferno*, here is
Dante Alighieri (1265–1321) being given
a guided tour of Hell by Virgil. He meets
(and takes his revenge on) many of his
contemporary enemies. It is illustrated
with an engraving after Sandro Botticelli
(1445?–1510). This is the third chasm.
Virgil is pointing out to Dante the
simonists (those who buy or sell
ecclesiastical promotions): 'The soles of
their feet were on fire; / Which made their
joints wriggle so violently / That they
would have broken ropes or withies.'
Ouch. Dante's was one of the first
literary works to be written in the Italian
vernacular rather than Latin. The metre
of Dante's *Divina Commedia* is terza rima.
This is a series of interlocking tercets, in
which the second line of each one rhymes
with the first and third lines of the one
succeeding, thus: *aba, bcb, cdc,* and so on.

71
The Tale of Kieu
Truyen Kieu or Kim van Kieu, by Nguyen Du
Or. 14844, f. 62

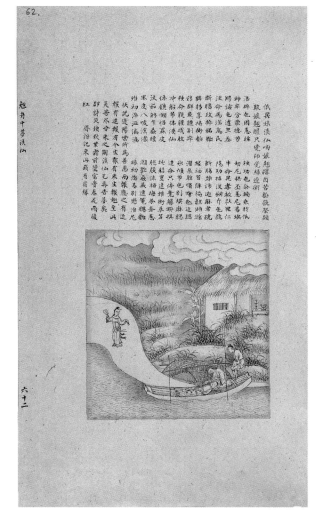

This is Vietnam's national epic. The poem
in 3,254 couplets was written between 1805
and 1820 by a government official. On
the surface it is the love story of a beautiful
and learned Vietnamese woman called
Vuong Thuy Kieu. After years of
Dickensian misfortunes as a concubine
and a singer in a brothel, she is allowed
a happy ending. Between the lines, the
subtext tells the story of the political and
personal conflict at the end of the feudal
period. Kieu's misadventures represent the
fate of all humans, including the author's,
in the cruelties and injustices of feudalism.
The more talented you are, the unluckier
you may be. It is an epic of a genre that the
Vietnamese call 'fated love' and redemp-
tion. Its subtitle is 'The New Scream that
Cuts Your Guts'. This edition in Sino-
Vietnamese characters was published
in 1894. Each page is illustrated with
incidents from the story of the misfortunes
and redemption of Lady Kieu.

72

Pope's Shield of Achilles
Alexander Pope's autograph draft
of his translation of Homer's *Iliad*
completed 1720
Add. MS 4808, ff. 81v–82

The autograph draft by Alexander Pope (1688–1744) of his translation of Homer's *Iliad* includes his train-spottingly precise drawing of the Shield of Achilles. Silver-footed Thetis, the sea-goddess, has asked Vulcan (the Latin name of Hephaestus, the Greek smith-god) to forge an impervious shield for her son, Achilles, to protect him from Hector and his Trojans. 'Then first he form'd the immense and solid shield; / Rich various artifice emblazed the field; / Its utmost verge a threefold circle bound; / A silver chain suspends the massy round…' Pope published the first volume of his translation in 1715. It was an instant success, in an age when every educated male was supposed to read Homer, both as

an intellectual *tour de force*, a treat for ladies (who were not expected to do Homer), and also as an aid to stumbling schoolboys. Homer is a natural torrent. Pope is a civilised English canal. Richard Bentley, the greatest English classical scholar, observed: 'It is a pretty poem, Mr Pope, but you must not call it Homer.' And Pope's version is indeed more classic Augustan than classical Homeric in both style and diction, but it has been widely admired. Coleridge (1772–1834) thought it 'an astonishing product of matchless talent and ingenuity'. Pope's contemporary, Jonathan Swift, no mean poet and author himself, sighed: 'In Pope, I cannot read a line, / But with a sigh, I wish it mine; / When he can in one couplet fix /

More sense than I can do in six: / It gives me such a jealous fit, / I cry, pox take him, and his wit.' The vast shield did not save Achilles. But it made Pope. It was the first bestseller in English, and enabled him to retire to Twickenham with his mother, to cultivate his garden (and grotto). Pope was the son of a Roman Catholic linen-draper of London. His health was ruined and his growth stunted by a severe illness at the age of twelve (probably Pott's disease, a tubercular affliction of the spine). His body was a sad joke, but his verses are the most polished in English. He put it himself: 'As yet a child, nor yet a fool to fame, / I lisp'd in numbers, for the numbers came.' In his own field, as miraculous as 'Homer'.

Mr. WILLIAM
SHAKESPEARES
COMEDIES,
HISTORIES, &
TRAGEDIES.

Published according to the True Originall Copies.

LONDON
Printed by Isaac Iaggard, and Ed. Blount. 1623.

A
DICTIONARY
OF THE
ENGLISH LANGUAGE:
IN WHICH
The WORDS are deduced from their ORIGINALS,
AND
ILLUSTRATED in their DIFFERENT SIGNIFICATIONS
BY
EXAMPLES from the beſt WRITERS.
TO WHICH ARE PREFIXED,
A HISTORY of the LANGUAGE,
AND
AN ENGLISH GRAMMAR.

By SAMUEL JOHNSON, A.M.

IN TWO VOLUMES.

VOL. I.

THE SECOND EDITION.

LONDON,
Printed by W. STRAHAN,
For J. and P. KNAPTON; T. and T. LONGMAN; C. HITCH and L. HAWES;
A. MILLAR; and R. and J. DODSLEY.
MDCCLV.

73
Shakespeare's First Folio
Title page incorporating a portrait
of Shakespeare engraved by Martin
Droeshout, printed by Isaac Jaggard
and Edward Blount, London, 1623
G.11631

The Shakespeare First Folio is the closest
that we can get to the plays as they were
originally performed. This first collected
edition of the plays was published in
1622–23, seven years after Shakespeare's
death. Of the 36 plays, half had already
been published as quartos during his
lifetime, though four were 'bad' quartos;
that is, they were reconstructed from
memory by a member, or members, of
their cast. So the First Folio gives the texts
of eighteen hitherto unpublished plays.
It was printed from sources that represent
the plays as performed in the theatre.
For example, *Hamlet* is 200 lines shorter
than the text in the second quarto,
perhaps because of cuts made during
performance. Behind the First Folio text
of *Hamlet* lies a manuscript other than
that from which the second quarto was
printed, possibly the prompt-book
released by the company of actors for
publication.

74
Johnson's Dictionary
A Dictionary of the English Language
by Samuel Johnson
First edition, 1755
680.k.12, title page

Published in two volumes in 1755,
Samuel Johnson's Dictionary is a
landmark of the English language. It set
the standards for subsequent lexicography,
with its definitions (some famously
playful), etymology (inchoate), and
illustrative citations. His original plan was
to fix the pronunciation of English and
to preserve its purity. But as he worked,
Johnson came to realise that this was as
lost a cause as King Canute's. Language
changes as irresistibly as the tides. 'If the
changes that we fear be thus irresistible,
what remains but to acquiesce with
silence, as in the other insurmountable
distresses of humanity? It remains that we
retard what we cannot repel, that we
palliate what we cannot cure.' This is the
only dictionary created by a literary giant.
Sam is the secular patron saint of the
English and their English.

75 >>
Edward Gibbon's Library Catalogue
Add. MS 34716 A

The personal library catalogue of Edward
Gibbon (1737–1794), England's most
erudite and witty historian, the author
of *The Decline and Fall of the Roman Empire*,
was written on the back of playing cards
which were bound into this volume.
Many of the books listed are today
dispersed among the different collections
at the British Library. Although his
private library was extensive, Gibbon
needed deeper sources for *Decline and Fall*.
So he was given permission to research in
the King's Library, now the centrepiece of
the modern British Library. His work is
great literature as well as great history. It is
pessimistic: 'History is, indeed, little more
than the register of the crimes, follies, and
misfortunes of mankind.'

76 >>
Jane Austen's Last Novel
Autograph manuscript of *Persuasion*, 1816
Egerton MS 3038, ff. 9v–10

This is the manuscript, with author's
emendations, of Jane Austen's *Persuasion*
(published posthumously). In it Jane's
ridicule and satire of the passing show take
a milder form than in her previous books.
The tone is more romantic and tender.
Populist belief (poorly substantiated)
maintains that a love story of the author's
own life is reflected in that of her heroine,
Anne Elliot. She is the second daughter of
Sir Walter Elliot, an archetypal English
snob and spendthrift. Anne, who is pretty,
intelligent and amiable, has been persuad-
ed to break off her engagement to a young
naval officer because of his lack of fortune
and a misunderstanding of his easy nature.
Reader, it has a happy ending. Jane wrote
to her niece Fanny: 'You may PERHAPS
like the heroine, as she is almost too good
for me.' The Library also holds the desk at
which Jane (1775–1817) composed some
of her novels. In a letter to her nephew she
referred to 'the little bit (two inches wide)
of ivory on which I work with so fine a
brush as produces little effect after much
labour.' Some brush! Some effect!

77
The Life and Adventures of Nicholas Nickleby
Charles Dickens' autograph manuscript
Opening of chapter XV
Add. MS 57493, f. 1

Charles Dickens (1812–1870) wrote
Nicholas Nickleby in nineteen monthly
instalments from April 1838 to October
1839. At the same time his prodigious
workload included finishing *Oliver Twist*
and several other books and articles.
Nicholas Nickleby is notable for achieving
one of Dickens' moral and social
campaigns: the purging of the notorious
Yorkshire boarding schools, represented
by Dotheboys Hall; and, in Wackford
Squeers, one of his most infamous
villains, who is both a monster and
a figure of fun.

78 >>
Jane Eyre
Charlotte Brontë's autograph fair copy
1847
Add. MS 43474, f. 1

Jane Eyre is among the classics of English
literature. The manuscript shown here
is the autograph fair copy of Charlotte
Brontë (1816–1855). In her biography,
Elizabeth Gaskell described Charlotte's
'clear, legible, delicate traced writing'.
The novel dramatises the conflict between
passionate desire and moral reasoning.
It gave women a voice equal to that of
men, while its sexual undercurrents
have subjected it to many Freudian
interpretations, encouraged by the
author's frequent use of dream imagery.
Additional scandal attended the
publication of the second edition,
which Charlotte dedicated to William
Thackeray (1811–1863), unaware that,
like Mr Rochester, he too had a wife
certified as insane. *Jane Eyre* ends
with the eponymous heroine's famous
declaration, 'Reader, I married him.'
Because of the Victorian prejudice against
'authoresses', Charlotte published under
the pseudonym Currer Bell. Her sisters,
Emily and Anne, wrote under the male
cloaks of Ellis and Acton Bell.

March — 16th

Jane Eyre

by Currer Bell

Vol. I.

Chap. 1st

There was no possibility of taking a walk that day.
We had been wandering indeed in the leafless shrubbery
an hour in the morning, but since dinner (Mrs Reed,
when there was no company, dined early) the cold winter
wind had brought with it clouds so sombre, a rain so pen-
etrating that further out-door exercise was now out of the
question.

I was glad of it; I never liked long walks — especially
on chilly afternoons; dreadful to me was the coming home
in the raw twilight with nipped fingers and toes and a heart
saddened by the chidings of Bessie, the nurse, and humbled
by the consciousness of my physical inferiority to Eliza, John
and Georgiana Reed.

The said Eliza, John and Georgiana were now clustered
round their Mamma in the drawing-room; she lay reclined

HERE BEGINNETH THE TALES OF CANTER-
BURY AND FIRST THE PROLOGUE THEREOF

Whan

THAT Aprille with his shoures soote
The droghte of March hath perced to the roote,
And bathed every veyne in swich licour,
Of which vertu engendred is the flour;
Whan Zephirus eek with his swete breeth
Inspired hath in every holt and heeth

The tendre croppes, and the yonge sonne
Hath in the Ram his halfe cours yronne,
And smale foweles maken melodye,
That slepen al the nyght with open eye,
So priketh hem nature in hir corages;
Thanne longen folk to goon on pilgrimages,
And palmeres for to seken straunge strondes,
To ferne halwes, kowthe in sondry londes;
And specially, from every shires ende
Of Engelond, to Caunterbury they wende,
The hooly blisful martir for to seke,
That hem hath holpen whan that they were
seeke.

Bifil that in that seson on a day,
In Southwerk at the Tabard as
I lay,
Redy to wenden on my pilgrym-
age
To Caunterbury with ful devout
corage,
At nyght were come into that hostelrye
Wel nyne and twenty in a compaignye,
Of sondry folk, by aventure yfalle
In felaweshipe, and pilgrimes were they alle,
That toward Caunterbury wolden ryde.

The Adventure of the Missing Three-Quarter.

We were fairly accustomed to receive weird telegrams at Baker Street but I have a particular recollection of one which reached us on a gloomy February morning some seven or eight years ago and gave Mr Sherlock Holmes a puzzled quarter of an hour. It was addressed to him and ran thus

"Please await me. Terrible misfortune. Right wing three quarter missing, indispensable tomorrow. Overton"

"Strand post mark and dispatched 9.36" said Holmes, reading it over and over. "Mr Overton was evidently considerably excited when he sent it and somewhat incoherent in consequence. Well, well, he will be here I dare say by the time I have looked through the Times and then we shall know all about it. Even the most insignificant problem would be welcome in these stagnant times."

Things had indeed been very slow with us, and I had learned to dread such periods of inaction for I knew by experience that my companion's brain was so abnormally active that it was dangerous to leave it without material upon which to work. For years I had gradually weaned him from that drug mania which had threatened once to destroy his remarkable career. Now I knew that under ordinary conditions he no longer craved for this artificial stimulus but I was well aware that the fiend was not dead but sleeping, and I have known that the sleep was a light one and the waking near when in periods of idleness I have seen the drawn look upon Holmes' ascetic face, and the brooding of his deep set and inscrutable eyes. Therefore I blessed this Mr Overton, who ever he might be, since he had come with his enigmatic message to break that dangerous calm which brought more peril to my friend than all the storms of his tempestuous life.

Dulce et Decorum est.

Bent double, like old beggars under sacks,
Knock-kneed, coughing like hags, we cursed through sludge,
Till on the haunting flares we turned our backs
And towards our distant rest began the trudge.
Men marched asleep. Many had lost their boots
But limped on, blood-shod. All went lame; all blind;
Drunk with fatigue; deaf even to the hoots
Of tired, outstripped Five-Nines that dropped behind.

Then somewhere near in front: Whew...fup, fop, fup,
Gas-shells? Or duds? We loosened masks in case,—
And listened. Nothing. Far rumouring of Krupp.
Then sudden poison hit us in the face.
Gas! GAS! Quick, boys! — An ecstasy of fumbling,
Fitting the clumsy helmets just in time;
But someone still was yelling out and stumbling,
And floundering like a man in fire or lime...
Dim, through the misty panes and thick green light,
As under a green sea, I saw him drowning.

In all my dreams, before my helpless sight,
He plunges at me, guttering, choking, drowning.

<< 79

The Kelmscott Chaucer
The Works of Geoffrey Chaucer
Illustrations by Edward Burne-Jones,
engraved on wood by W. H. Hooper,
The Kelmscott Press, Hammersmith, 1896
C.43.h.19, Prologue

'Dan Chaucer, well of English undefiled, / On Fame's eternal beadroll worthy to be filed.' These are Edmund Spenser's words of praise for one of Britain's best-loved poets, Geoffrey Chaucer (1343–1400). This edition of *The Canterbury Tales*, by a founding father of Western literature, was the jewel in the crown of the Kelmscott Press, founded in Hammersmith in 1891 by artists William Morris and Edward Burne-Jones. It was five years in planning and took two years to print. And it represents Morris's rebellion against the mass production of contemporary mechanised Britain.

80

A Sherlock Holmes manuscript
Sir Arthur Conan Doyle, *The Adventure of the Missing Three-Quarter*
Add. MS 50065, f. 2

The game's afoot. A gloomy February morning. Baker Street. A weird telegram is delivered. Sherlock is the most famous fictional detective in the world. Societies celebrate his adventures worldwide. He became, however, an embarrassment to Conan Doyle, his author, who preferred his more serious work. His papers were dispersed in 2004. The British Library obtained a significant corpus of the literary phenomenon, including this manuscript. Holmes still inspires more film and television than any other fictional character, including Robin Hood. The Library also has a recording in its Sound Archive of Conan Doyle talking in 1930 about the genesis of Holmes.

81

Dulce Et Decorum Est
Wilfred Owen's autograph draft, *c*.1917
Add. MS 43720, f. 21

This draft is from the collection Wilfred Owen (1893–1918) was working on at the time of his death, a week before the Armistice that concluded the First World War. His poems conveyed the horror of life at the Western Front to an ill-informed and largely complacent audience in Britain. 'My subject is War and the pity of War. The Poetry is in the Pity.' Owen's bleak realism, his energy and indignation and his compassion are evident. Note the sarcastic reference in the title of the poem to Horace's unpersuasive claim that it is 'a sweet and fitting' thing to die for one's country.

1797.

im Jenner

6 Stücke. 2 violini, 2 flauti, 1 flauto piccolo, 2 oboe, 2 clarinetti, 2 fagotti,
2 corni, 2 clarini, timpany e Basso.

Wien.
im 17 Merz.

Ein Rondò für das Clavir allein.

im 18

Scena für fl. heffer von dei' wie mere, Begleitung. 2 violini, 2 viole,
1 flauto, 2 oboe, 2 fagotti, 2 corni e Basso.

im 25

Ein Duett für fl. yesserd von Jacquin. Mentre ti lascio o figlia C.
Begleitung. 2 violini, 2 viole, 1 flauto, 2 clarinetti, 2 fagotti, 2 corni e Basso.

im 19 April

Ein quittett für 2 violini, 2 viole und violoncello.

Andante [Rondò]

Recit.ᵗ Alltᵗ

Leghtto.

Allᵗ

09 Music

82
Mozart's Thematic Catalogue
Entries for early 1787
Zweig MS 63, ff. 10v–11

This is the personal record kept by Wolfgang Amadeus Mozart (1756–1791) of his compositions during the last seven years of his life. No other master of music has kept such a chronological list of this quality. The left-hand page gives the titles or descriptions of the compositions and, for the operas, the names of the singers at the first performance. The right-hand page is ruled with ten staves grouped in pairs, on which he wrote the first few bars of the music. It is a surprisingly efficient catalogue when one considers his chaotic way of working. This opening shows five pieces composed in the early months of 1787, including (at the bottom) his String Quintet no. 3 in C major (K. 515), which he completed on 19th April.

Aoide, the Muse of singing, is the English Muse. Brit Pop sings worldwide. Choral singing is the musical form at which the British excel. Choirs and choral societies carol throughout the land. And the Library preserves their songs, on tape, notation and other methods of recording the most ephemeral of arts, from the earliest times. Whether the homesick legionnaires posted up at Vindolanda on Hadrian's Wall sang rather than recited Horace's Odes is the latest hot debate by scholars. They sang, but we have lost the tunes. The Library has no record of British song quite that old. But its records stretch back many centuries. The Old Hall Manuscript echoes English song from six centuries ago. The spring song 'Sumer is Icumen in' is even older, and excitingly problematic. It dates from the early part of the thirteenth century, yet it has a contrapuntal complexity that belongs to the fifteenth. It may be an actual folk song from the dawn of English choral singing. The alternative sacred words in Latin fit the music badly. It is the oldest hit in the English repertoire.

Wildly different, but in the same old tradition, is the biggest hit by The Beatles, 'I Want to Hold Your Hand', scrawled and annotated by Paul McCartney. The British Library also holds Mozart's personal (and surpringly well-organised) catalogue of his compositions, as well as Bach's autograph manuscript of *The Well-Tempered Clavier*, the title of his 48 Preludes and Fugues. This compromise in tuning was a turning-point in Western music. Some think that Bach invented the system. It is, however, said to have been proposed by Aristoxenus (c.350 BC), and to have been in use in China centuries before that. The Library holds the manuscripts to answer such puzzling questions that are not beyond all conjecture.

Here also the curious may discover Handel's draft for the *Messiah*, still the most popular choral work for modern British choirs. Aoide can find the answers to the puzzles in Elgar's *Enigma Variations*, as well as the earliest examples in print of English popular songs: 'Immortal Science too, be near! / (We own thy Empire o'er the Mind)' – a hit song of 1737 in the Vauxhall Gardens from *The Musical Entertainer*. Not *Top of the Pops* today. For the Library is full of the world's music, recorded in autograph and print, on tape and disc and more.

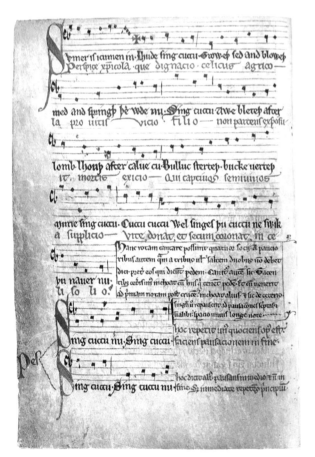

83
Windsor Carol Book
Egerton MS 3307, f. 72v

This Latin drinking song 'O potores exquisite', ('O elite boozers'), set for three voices, is from the Windsor Carol Book, a collection of carols and other music probably written for St George's Chapel at Windsor Castle between 1430 and 1444. Carols were not exclusively associated with Christmas in the Middle Ages, and this collection includes texts in Latin, English and French on a variety of subjects including the Wars of the Roses and the Battle of Agincourt, as well as liturgical music for Holy Week and Easter. The words of this drinking song are also found in the famous Carmina Burana manuscript, but this is the earliest known musical setting.

84
Sumer is Icumen In
Harley MS 978. f. IIv

One of the earliest known examples of English polyphony, this six-part round, composed c.1250–70 with words and music, is the most famous of all medieval music manuscripts. The melody is one of the oldest known examples of ground-bass (ostinato) and the manuscript is the earliest known in which both secular and sacred words are written to the same piece of music. Instructions on how to perform the round are written in Latin in text insets. The song gives a cheerful message to islanders who have always been obsessed by the often discouraging climate.

85
The Old Hall Manuscript
Add. MS 57950, ff. 55v–56

The Old Hall manuscript is one of the most important and substantial collections of early English part music. It was mainly compiled by one scribe between 1415 and 1421, with additions in several other hands from the early 1420s, and mainly consists of settings of chants for the Mass, but also motets and other music. Composers' names are given, unusually for such an early collection, and this page shows part of one of the later additions, 'Veni sancte spiritus' by the most famous English composer of the later Middle Ages, John Dunstaple.

86
J. S. Bach's Well-Tempered Clavier
Autograph manuscript, Book II, 1740–42
Add. MS 3502, f. 14

Here is a detail from the beginning of the autograph of Bach's fugue in A flat major, from *Das Wohltemperierte Klavier*. This work is a turning point in musical history. It was Bach (1685–1750) who established the tuning of the modern piano in such a way as to enable modulation in all 24 keys – and this piece demonstrated that it worked. (For 'well‑tempered clavier', read 'well‑tuned piano'). Bach was the father of the modern Western octave and the modern piano. If this collection of preludes and fugues was composed with the aim of teaching particular techniques, the individual pieces are also, of course, more than technical exercises; they are admirable in their wonderful variety of subject, texture, form and treatment.

87
The Musical Entertainer
Vol 1, Title Page
K.10.b.12.

This is one of the earliest examples of printed music, published between 1737 and 1739, by George Bickham. He was the most celebrated and controversial engraver of the century. The government censors were continually seizing the stock from his shop for its supposed subversive or pornographic contents. *The Musical Entertainer* was his most ambitious and ground‑breaking venture. Its two volumes printed the music and words for 175 popular songs of the period, handsomely illustrated with

engravings often plagiarised from contemporaries such as Hogarth. The sentimental songs, with titles such as 'The Melancholy Nymph' and 'The Pensive Swain', were the current top of the pops in Vauxhall Gardens, which was the eighteenth‑century equivalent of a non‑stop pop festival and pleasure ground. It was so expensive a publication that Bickham published it in parts, cunningly dedicating each fascicle to a duke or a duchess, or other nobility and gentry.

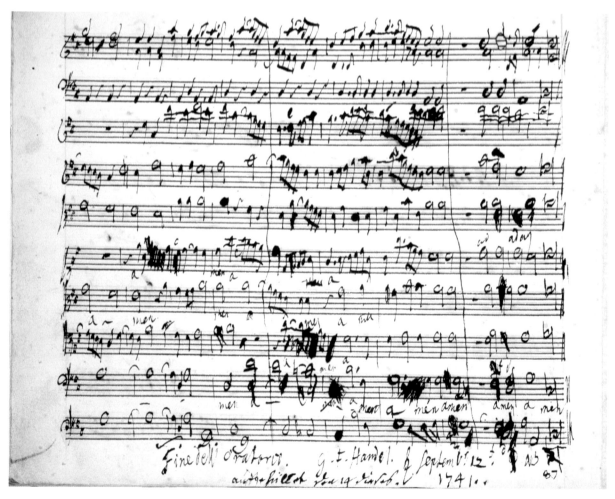

88

Handel's Messiah
Autograph composition draft, London,
12 September 1741
R.M.20.f.2, f. 132v

The Messiah is still the most popular choral work in Britain, and George Frideric Handel (1685–1759) is one of the greatest 'English' composers. He was born at Halle, in Saxony, in the same year as Bach, and sprang from a similar North German middle-class family. He was brought up in the same Protestant environment. Like Bach, Handel represents the climax of the late contrapuntal school. But their careers and music differed widely. Whereas Bach was intensive, Handel was extensive. Bach did not stir from North Germany, and remained a member of the lower middle-class in which he was born. But Handel became a cosmopolitan man of the world, on familiar terms with the more intelligent members of the idle aristocracy, while at the same time he was worshipped by the prosperous middle classes. He composed operas and oratorios for large audiences. As a bachelor he could make and lose fortunes in his speculations in public entertainment, at a time when Bach was eking out a small but regular income and rearing his large family. From 1712 Handel lived in London, and composed his best work there. His composition score for *The Messiah*, shown here, took only 24 days to complete and filled 260 pages of manuscript. Handel spoke of having composed it under the influence of great emotion: 'I did think I did see all Heaven before me – and the great God himself.'

This page shows the beginning of the second part, 'Behold the Lamb of God, that taketh away the sins of the world' (John 1:29). The tradition that, during a performance, the audience rises to its feet for the 'Hallelujah Chorus' is uncanonical, based on a misunderstanding of the short attention span of George II while listening to it. The King rose to his feet, possibly because of a bad case of pins and needles or gout, rather than an outburst of royal emotion inspired by the music. We do well to honour the mistaken tradition. Haydn, hearing the Hallelujah Chorus in Westminster Abbey, rose to his feet with the crowd, wept, and exclaimed: 'He is the master of us all.'

I wanna hold your hand .
Oh yea, I'el tell you Something
I think you'll understand
When I Say that Something
I wanna.
Twice

Oh please Say to me
you'll let me be your man
and please Say to me
you'll let me hold your thing.

And when I touch you
I feel happy inside
It's such a feeling that my love
I can't hide etc. .
Oh you got that something
I think you understand
When I feel that Something
I wanna hold your hand .

3/10 See me .

Written in Paul's hand- composed by
Paul & John in Jane Asher's basement.

<< 89

Elgar's Enigma Variations
Variations on an Original Theme,
op. 36, 1889–99, autograph:
Variation 9 ('Nimrod')
Add. MS 58004, f. 36

Edward Elgar's *Variations on an Original
Theme* ('Enigma') portray the characters
of the composer's friends. First performed
in London in July 1899, this was the
first work to bring public recognition to
Elgar (1857–1934), the most English of
composers. Variation XIII ('Nimrod') is
one of the best-known English melodies.
Nimrod, 'the mighty hunter', is a pun on
the name of Elgar's publisher and guru,
August Jaeger (German for 'hunter').
This is the only one of Elgar's works that
is played in every musical centre in the
world. For, inexplicably, he remains an
'English composer', known outside his
own country by name and fame more than
by performance.

90

The Beatles' Biggest Hit
'I Want To Hold Your Hand'
Composed in 1963 by John Lennon
(1940–1980) and Paul McCartney (1942–)
Loan 86

This is the song that made The Beatles,
'the Fab Four', a sensation of the Sixties
on both sides of the Atlantic. The first
Beatles song to be recorded on 4-track,
it went to the top of the UK charts
in December 1963. Written with the
American market in mind, it also
became The Beatles' best-selling single
worldwide. The manuscript here is in
Paul McCartney's handwriting. You do
not have to agree with the music critic of
The Times that Lennon and McCartney
were the greatest songwriters since
Schubert, but you should recognise the
social as well as the musical phenomenon.

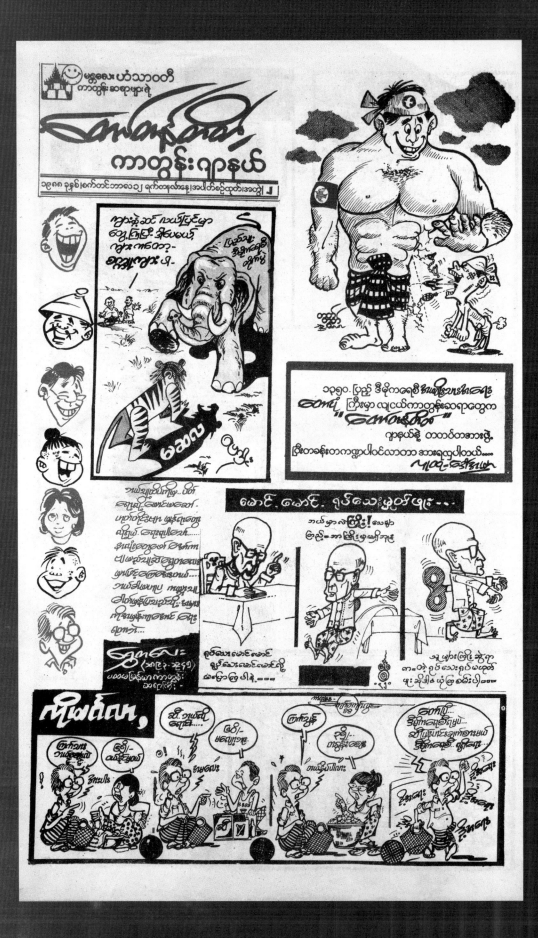

10 Asia

91

Burma's Pro-Democracy Demonstrations of 1988

Cartoon journal, issue no. 2,
12 September 1988
ORB 45/54/96

In a brief sunshine spell of freedom for Burma in 1988, mass pro-democracy demonstrations called for an end to General Ne Win's one-party socialist rule. Hundreds of news journals, newspapers and pamphlets were produced. They reported the nationwide strikes, rallies and debates, and carried cartoons and poems giving a voice to citizens' hopes for democracy, human rights and freedom of expression. This page carries an endorsement from a leading Mandalay writer, Ludu Daw Ahmar. Top left, the people's democracy elephant confronts the rulers' paper tiger. In the middle, Dr Maung Maung, the temporary civilian president, denies that he is a puppet whose strings are pulled by the military dictators. However, he is depicted as a wind-up robot. At the bottom, a man exclaims in horror at the high price of chicken, oil and onions. He rushes off to join the democracy movement: 'Only then will people be able to afford to cook and eat chicken curry.' In the September of this publication, a military junta, the State Law and Order Restoration Council, took control, arrested the democracy activists, and reimposed censorship. Most of the publications by the democracy movement were burnt. The British Library holds the unique collection of the publications of this brief period of Burmese independence. Then darkness descended again.

The earliest of the British Library's links with Asia can be found in the ancient Buddhist objects from Dunhuang. Britain's links were formally forged with the foundation of the East India Company in 1600. India became the Jewel in the Crown of British imperialism. Britain's foreign policy in the Far East depended on India. The movement of Indian opium to China was an important link for many decades. And the administration and army in India shaped the employment and outlook of the British middle classes. The Library holds the archives of the East India Company. So there are the records of viceroys and sepoys, of engineers and big-game hunters, the terse campaign communiqués of Arthur Wellesley (later Duke of Wellington), and a letter home from a British private describing 'the outbreak of India or the revolting of the sepoys'. The last viceroy dispatches his way reluctantly towards partition, which produced the modern states of India and Pakistan. There are paintings of Indians and flowers and elephants by British memsahibs and girls 'out with the fishing fleet' to catch a husband. There are satirical cartoons and ceremonial canvases for the ruling elite. The earliest written accounts and illustrations of the Hindu scriptures can be found in London. Good as well as ill came from the British Raj in India. And there was much more to it than a mutual love of cricket, railways and bagpipes. Kipling was its historian poet. But England, like Kipling, was in love with more of the East than just India. And the old affair shows in the Library.

Here are the rare surviving magazines and posters from that short period of daylight in 1988 when Burma had free speech, before censorship plunged it back into Myanmar. The rest is silence. The military junta destroyed the others. The only theological textbook of debates between Christian and Muslim clerics from seventeenth-century Esfahan (in modern Iran) is in the Library. In a lesson for their descendants, it argues that both Muslims and Christians believe in the same God, and should therefore show tolerance to each other. The first photographs of Tokyo were taken a century and a half ago by a British teacher in the Austrian East Asian Expedition. Meanwhile black London city gent umbrellas were the latest fashion item in Thailand in 1877. If you want to understand the call of the East for Britons, go to London, young man.

92

Two Faiths in New Julfa

Manuscript in Armenian and Arabic,
Esfahan, seventeenth century
Or. 15894, ff. 49v–50r

This is the only surviving copy of the
Textbook of Disputation of Yovhannes
Djughayetsi, 'the Unworthy', of New
Julfa (1643–1715). He was a prolific
Christian theologian, exegete and
philosopher in New Julfa, which was
a privileged Armenian Christian enclave
of Esfahan (in modern-day Iran), then
within the Muslim Safavid empire.
There Yovhannes conducted debates
with Muslim clerics. He wrote, scribed
and illuminated this manuscript in
Armenian and Arabic for use during
these debates. In it he argues that both
Christians and Muslims have the same
concept of the Essence of God, and that
the external differences should not be a
reason for persecuting the Christians.

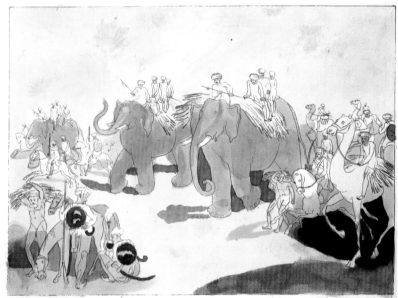

93

Oriental Manners and Customs

Robert Mabon, probably Calcutta, 1797
T39881, Plate VI

This painting is from a 1797 book that
was probably the first cheap pictorial
representation of Indian manners and
customs. Subscribers included Sir John
Shore (the Governor General), the Hon.
Colonel A. Wesley (later Wellesley,
still later the Duke of Wellington) and
William Hickey (the Calcutta attorney
and diarist). This plate is entitled:
'Mahratta Pendairees returning to Camp,
after a plundering excursion during
the late Savoy Mahadowrow Pundit
Purdhun, late Peshwa of the Mahratta's
Expedition against Nizam Ally Khan.'
Pendairees (or pindaris, plunderers
who drank the intoxicating *pinda*) were
freelance guerrillas, who would serve
under any chief at war. According to the
artist, 'All the compensation they require
is an unlimited power, wherever they are
encamped with the army, to plunder the
country. If in the encampment of the
chief, under whose banners they fight,
they content themselves with seizing what
grain is necessary for their subsistence.'

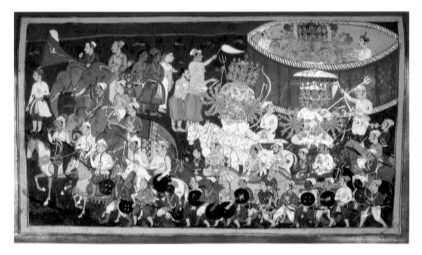

94
Ravana and his Troops
From the *Ramayana*, Yuddha Kanda,
illustrated by Sahib Din
Udaipur, 1652
Add. MS 15297, f. 138r

The *Ramayana* is a great Indian epic.
Rama is its hero, an incarnation of the
god Vishnu. Exiled to the jungle with his
wife Sita and brother Lakshmana, he
fought against the powers of darkness in
the form of a demon king, Ravana. The
demon was omnipotent against gods and
other demons, but not against mortals.
So the god in human form was able to
defeat him, because of his humanity.
In the picture, Ravana emerges from his
bath, clad in golden armour spangled
with flowers, under a parasol, and mounts
his chariot drawn by eight horses. The
final showdown is nigh. His ally is the
monkey-god Hanuman with his monkey
army. The host of gods attended the last
contest. Rama then reigned as a king on
Earth, before returning to Heaven to be
reunited with his divinity.

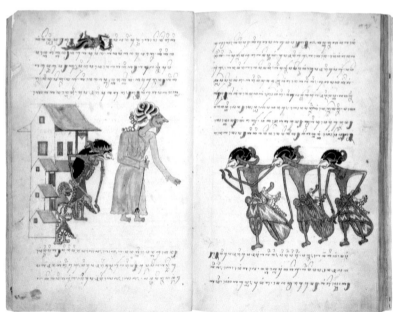

95
The Story of Selarasa
Selarasa and his brothers pay respects
to a holy man, made 4 June 1804
IOL Jav 28, ff. 13v–14r

Selarasa was a mythical prince of
Champa (now called Cambodia).
This early Javanese manuscript was
written and illustrated in 1804. In the
picture Selarasa, on the far right, with
two of his brothers, is saluting a holy
man. The sage's daughter, Ni Rumsari,
has dreamt that three handsome men will
come to pay a visit. Behind her stands a
female servant from eastern Indonesia.
According to the conventions of Javanese
illustration, high-ranking people are
depicted in profile, in the stylised form of
wayang kulit, puppets from the Javanese
shadow theatre. Figures of lower rank
are depicted naturalistically. The size of
the characters symbolises their relative
status. The dragon-like motif on the
first line of text on the left-hand page
marks the boundary between two cantos
of the poem.

Dear Brother this concern
was the cause of my neglect
for noting writing to you before
now So Dear Brother the
date of your letter which you
favoured me with was February
the 15. The year of our Lord 1857
Nothing gave me more pleasure
than to hear you was in the
enjoyment of good health which
the date of this letter leaves me
in at present thanks bee to
God for it Dear Brother
I hope you will be good enough
as to give my best respects to
all requiring friends and to
those friends of mine yr who

Now or living in america
please to let me know
if they all are enjoying good
health I hope they are I all as
well as I am at present This
I hope you will be good enough
as to let me know of in your
next letter do not forget doing
this as it might be necessary
for me to know So my Dear
Brother I beg to State for your
information how I am in the
points of going home in the lattrent
of this season the place where
I am now is a healthy Spot
where the Sick is sent for the
benefit of their health anually
and a good many is sent away

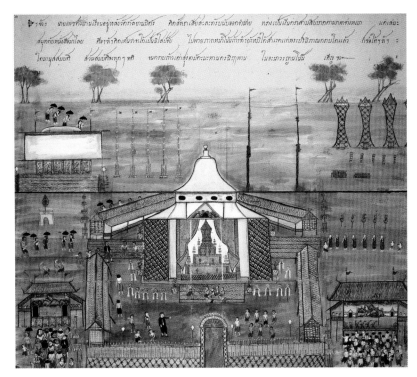

96
A Soldier's Letter of 1859
IOR MSS Eur F133/76

This letter from a British soldier, dated 4th June 1859, refers to 'the outbreak of India or the revolting of the sepoys'. The Indian Mutiny, often known to Indians as the first Indian War of Independence, raged from 1857 to 1859, with great cruelty on both sides. Fear of change from above imposed by an alien power was aggravated by two twists. There was one widely credited rumour that the cartridges for the new Enfield rifle were greased with a blend of pork and beef fat, and another that the powdered bones of pigs and cows had been surreptitiously added to ration flour issued to sepoys of the Bengal army. Hindu and Muslim alike took grave offence. The Mutiny failed because it had no common purpose, and was put down by British troops marching round the different centres of insurgency. It led to the dissolution of the British East India Company, the end of the Mughal Empire and the formal beginning of direct rule – the Raj.

97
Phra Malai and Birth Tales
Thai manuscript painting, 1877
Or.16100, f. 49

The story of Phra Malai tells of a monk who travelled to Buddhist heaven and hell. It has been recited orally in Thailand for centuries, but was written down only in the late eighteenth century. These manuscripts were produced as an act of merit, to honour the funeral of a dignitary. This picture illustrates the funeral of a high-ranking monk. The coffin is laid in the centre of a Buddhist monastery. In front of it, a monk is reading from a palm-leaf manuscript. Lay people crowd the monastery compound, most of them carrying Western black umbrellas – the latest fashion in nineteenth-century Bangkok. The funeral of a VIP in Thailand has a carnival atmosphere: there are puppet theatres on either side of the monastery. In the one on the right an episode from the *Ramakien* (the epic of Rama) is being performed. Realistic illustrations of such events are extremely rare.

Japan!

Am Fort Susaki in Jedo.

98
Fort Susaki at Yedo (Tokyo)
Photograph by Wilhelm Burger, 1869
CS 113–02

Here is one of the earliest photographs of Tokyo. It was taken in 1869 by Wilhelm Burger, a teacher of the new art of photography at Vienna University, whence he was appointed official photographer to the Austrian East Asian Expedition of 1868–70. The purpose of the expedition was to strengthen diplomatic and commercial links between the Austro-Hungarian Empire and the countries of the Far East. Burger's photographs record the vanished faces of Japan, China and Thailand.

99
The Koochpurwanaypore Swadeshi Railway
Drawing by 'Jo Hookm'
ORW 1986.c.29, p. 52

52 THE KOOCHPURWANAYPORE RAILWAY.

THE FLYING TRAIN.

The Board of Directors of the K. P. R. have been profoundly impressed with the recent drastic proposals to establish aeroplane services in various parts of India, and came to the conclusion that the days of Railways had come to an untimely end. They therefore at once came to the conclusion to convert all their rolling-stock for aeroplane service, so immediately set about this thorough change. The locomotives with a very little alteration (as seen) have been made into flying engines, and the needful wings and stays added to the rolling-stock, and there you are !! Just think what this change means. Their permanent way has all been dug up and sold for scrap-iron. The permanent way Engineers, Assistants and staff have all been dismissed. All bridges, cuttings, embankments, tunnels, etc., are no longer required. All signals and interlocking gear, block instruments and appliances and staffs have been abolished. Think of the saving in maintenance ! So the Directors joyfully anticipate a dividend of about 300 per cent, for the first half-year.

This satirical cartoon was published in the magazine of the Great Indian Peninsula Railway, probably in 1920. It shows a flying railway train. The text notes the prodigious expense of running conventional locomotives across India. The Board of Directors of the KPR have therefore decided to convert all their rolling-stock to flying-stock. With very little alteration, the locomotives have been made into flying engines. Their permanent way has been dug up and sold for scrap-iron. Bridges, cuttings, embankments and tunnels are no longer required. The railway staff have been dismissed. 'Think of the saving in maintenance! So the Directors joyfully expect a dividend of about 300 per cent for the first half-year.' At this time nationalists were agitating for Indians to be given a role in the management of the railways. The acidulous imperialist response in this series of cartoons includes a submarine train, a train hauled by an elephant, and a pedestrian signal that runs along the track ahead of the trains. The fantasy place-name Koochpurwanaypore means 'It-doesn't-matter-city'. Similarly the artist's name translates as 'At your service'. Can he be the same elusive Raja Joe Hookham mentioned in *Hobson-Jobson*?

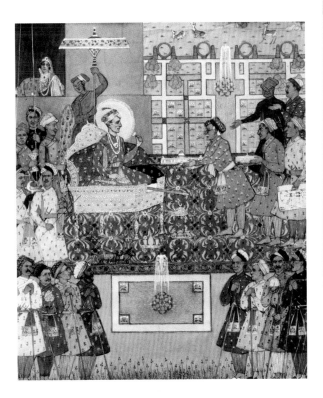

100
The Viceroy as Mughal Emperor
Illustration in *Indian State
Railways Magazine*, February 1931
SV 14, vol. IV, no. 5, facing p. 466

Here, Sir Edwin Lutyens (1869–1944)
and Sir Herbert Baker (1862–1946),
principal architects of New Delhi, are
presenting models of their buildings to
Lord Irwin, the Viceroy. The occasion
is the inauguration of New Delhi as the
capital of India. The painting, in the
Persian Mughal style, is by an unknown
artist. The setting and costumes are
Indian, but the faces are European.
The key alongside identifies the figures,
from Lady Irwin (top left) to the two
viceregal dogs (centre left). The punkah-
wallah pulling the fan behind the Viceroy
is, significantly, the only figure with no
name.

101 >>
A Final Blast from the Raj
Letter from Earl Mountbatten
of Burma to Sir Evan Jenkins, 1947
IOR R/3/1/176, ff. 220–21

This is one of the last official dispatches
from the last Viceroy of India, before the
partition that created the independent
states of India and Pakistan. It is sent to
the Governor of the Punjab. The Catch-
22 of constitutional reform for India was
to reconcile the claims of the Muslim
League, representing the powerful
Muslim community, with those of the
Indian National Congress, representing
the large Hindu majority with some
Muslim adherents. By now Mohammed
Ali Jinnah, President of the League, was
determined to secure a separate Muslim
state before the British relinquished their
Raj, in just over one month's time. For the

sake of immediate independence, Gandhi
and the Congress were prepared to accept
the necessity of India's partition, provided
that non-Muslim areas should not be
included in Pakistan against their will.
The Punjab, then as now, was a cockpit
of strife. So Pakistan came into being.
The name was coined for the four north-
western provinces of British India. It is
an acronym formed from Punjab, Afghan
(i.e. Pathan, for North-West Frontier
Province), Kashmir and Baluchistan.
On 15 August 1947, the Dominion of
Pakistan came into existence, and Jinnah,
Quaid-i-Azam (Great Leader), became
its first Governor-General.

No. 46/5.

THE VICEROY'S HOUSE.
NEW DELHI.

28th June, 1947.

Dear Jenkins, 63-71

Thank you for your most interesting letter of 25th June about the situation in the Punjab.

2. I appreciate the type of trouble that you are up against in Lahore and Amritsar and I took pains to explain to the Cabinet at the last meeting exactly what the difficulties are and why it was considered that martial law would not be effective.

3. The tendency to 'blame it all' on the officials and especially on the British officials is difficult to bear but you know the psychology behind it all, and of course if all three parties could agree to the appointment of a set of local officials in Lahore whom they would pledge themselves to support, it would make a great deal of difference. Merely to prove their previous allegations right, they would probably see to it that the trouble stopped. I realise how strongly you will feel that any transfers at this stage will be unfair to officers who have done remarkably well in an almost intolerable situation. But the time is exceptional and those who feel they must go will soon be free to go with compensation and proportionate pension. Though they may resent the injustice of the allegations against them I expect few of them will be sorry to have a rest.

4. You have had a message saying that the Congress and the League have agreed that you should appoint two sets of advisors, one for East Punjab and one for West Punjab. I hope you will find that the local leaders will accept the instructions of the High Command and join you at once.

than she expected : before she had drunk
half the bottle, she found her head pressing
against the ceiling, and she stooped to save
her neck from being broken, and hastily
put down the bottle, saying to herself "that's
quite enough—
I hope I sha'n't
grow any more—
I wish I hadn't
drunk so much!"

Alas! it
was too late:
she went on
growing and
growing, and very
soon had to
kneel down: in
another minute there was not room even for
this, and she tried the effect of lying
down, with one elbow against the door,
and the other arm curled round her
head. Still she went on growing, and as
a last resource she put one arm out of
the window, and one foot up the chimney,
and said to herself "now I can do no
more — what will become of me?"

11 Children

102
Alice Drinks from an Unlabelled Bottle

Lewis Carroll's autograph manuscript
Alice's Adventures Under Ground, 1862–64
Add. MS 46700, f. 19v

Charles Lutwidge Dodgson (1832–1898), better known as Lewis Carroll, was a mathematics don at Christ Church, Oxford. He first told the tale of Alice in Wonderland to entertain Alice, Lorina and Edith Liddell, the daughters of his college dean, while on a boat trip up the Cherwell on 4 July 1862. In the tale, Alice dreams that she chases a White Rabbit down a hole, where she encounters such celebrated characters as the Duchess and the Cheshire Cat, the Mad Hatter and the Mock Turtle. The girls adored the story, and begged Carroll to write it down. He took great pains to write in this neat 'manuscript print', designed for Alice to read. Then he added the illustrations of his vision of Wonderland and its inhabitants. He presented this manuscript to Alice with the inscription, 'A Christmas Gift to a Dear Child, in Memory of a Summer Day'. The manuscript of 'Alice's Adventures Under Ground', now in the Library, was published in 1865 as *Alice's Adventures in Wonderland*. It has become the most famous of all children's books, exemplifying such English idiosyncrasies as wordplay, whimsy and fantasy, with Freudian undertones for critics who hunt such Snarks. A contemporary reviewer attributed its success to the fact that it has no moral and does not teach anything, unlike other Victorian children's books. Adults find it as engaging to read as children do.

Some children's literature is ancient. The Romans sang lullabies. And some children's games (dibs or knucklebones) and nursery rhymes are as old. The earliest dissected map jigsaw puzzle is held by the Library. But books written for children did not appear before the eighteenth century. Those children who could read seized upon such adult works as Aesop's fables, popular ballads and romances, and fairy stories.

Children's books were originally instructive and uplifting. Puritanical tracts aimed to inculcate morality, and instructional works taught reading and general knowledge. The first specifically children's book, *Tommy Thumb's Pretty Song Book*, was published some time after 1744. The Library holds the only complete copy of this Gutenberg Bible of children's literature. It also has the only surviving copy of the first edition of *Goody Two-Shoes*, another archetypal granny of children's books. *The Butterfly's Ball* broke the mould of moral uplift. It introduced fantasy and fun for their own sake, and also animal anthropomorphism. As such, it pupped a long and distinguished litter, from Ratty and Mole and Pooh and Piglet to *The Sheep Pig* and *Charlotte's Web*. The interest in folklore helped to blow away the puritan moralists, and gave children Robin Hood, King Arthur and the fairy stories by the scholarly brothers Grimm. Edward Lear's *Book of Nonsense* was as anarchic as any rebellious child could wish. Lewis Carroll's *Alice's Adventures in Wonderland* not only avoided moralising didacticism, but actually made fun of it. Here is his neat autograph manuscript with his own illustrations for his real Alice in a boat up the River Cherwell.

From this beachhead that children's books should give pleasure before instruction or moralising, the rich diversity in the British Library grew. The genres include adventure, fantasy, animal anthropomorphism and picture-books. Some have long shelf lives even outside the Library. Kipling's *Just So Stories* and Beatrix Potter are still 'writes of passage' in the nursery. *Tom Brown's Schooldays* spawned the English tradition of school stories, enjoyed by children who had no desire or expectation of going to boarding school. Quentin Blake is a modern master artist for this generation of children, illustrating the antimorality fantasies of that other modern master, Roald Dahl. The wheel has turned full circle. Adult covers for Harry Potter and Tolkien preserve the dignity of grown-ups reading children's books on the Underground.

28

My Mill grinds.

My Mill grinds
Pepper, and Spice,
Your Mill grinds
Rats, and Mice.

TRILLETTO.

29

Bah, Bah, a black Sheep.

Bah, Bah a black Sheep,
Have you any Wool,
Yes merry have I,
Three Bags full,
One for my Master,
One for my Dame,
One for my little Boy
That lives in the lane.

103

The First Nursery Rhyme Book
Tommy Thumb's Pretty Song Book
Vol. 2, 1744
C.59.a.20, ff. 28–29

This is the Gutenberg Bible of children's literature. It was, until recently, a unique (and still is the only complete) copy of the first English nursery rhyme book. Nursery rhymes long existed as an oral tradition, but were not collected until 1744, when Mary Cooper published *Tommy Thumb's Pretty Song Book Voll.* [sic] *II*, apparently preceded shortly before by *Tommy Thumb's Song Book*. No copy is known of the first volume. The words of 'Bah, Bah, a black sheep' have scarcely altered in 200 years. Today children are taught to sing: 'Baa, baa, black sheep, / Have you any wool? / Yes, sir, yes, sir, / Three bags full; / One for the master, / And one for the dame, / And one for the little boy/ Who lives down the lane.' Old wives' and pedants' tales deconstruct the meaning of nursery rhymes. In the wool trade the division of the bags is said to refer to the export tax on wool imposed in 1275. The words are sung to the old French tune 'Ah! Vous dirai-je, maman'.

104

An Early Jigsaw Puzzle
Map of Europe by John Spilsbury, 1766
Maps 188.v.12

Board games for children began to be produced commercially during the eighteenth century. The games included dissected puzzles that had to be fitted together, featuring maps pasted onto boards and then cut into pieces around political boundaries. They were intended for use as aids in teaching geography. These earliest jigsaw puzzles were produced by a young London engraver, John Spilsbury. This map of Europe belongs to a set of four dissected maps of the continents then known (that is, excluding Australia). Each of the maps fits inside an oak box, with the title repeated on the lid and a key map pasted to the inside. Spilsbury's dissected maps lacked the interlocking pieces of modern jigsaws, which began to appear from the early 1780s.

105
A Unique Moral Tale
The History of Little Goody Two-Shoes
Printed for J. Newbery, London, 1765
C.180.a.3, ff. 44–45

This is the only copy of the first edition
of a long-lived moral tale. It is a variation
on the Cinderella story. 'Goody Two-
Shoes' is the nickname of a poor orphan
girl named Margery Meanwell. She goes
through life with only one shoe. When
she is given a pair by a rich gentleman, she
is so happy that she tells everyone that she
has 'two shoes'. Later, Margery becomes
a teacher, and marries a rich widower.
So her virtue is rewarded, a popular theme
in such inchoate children's literature.
Cynics have made 'Goody Two-Shoes' a
nickname for an excessively or annoyingly
virtuous person. The tale is said to have
been written by the Irish writer and hack,
Oliver Goldsmith, Dr Johnson's friend.
Garrick teased him: 'Here lies Nolly
Goldsmith, for shortness called Noll, /
Who wrote like an angel, but talked like
poor Poll.' But Johnson, in his Latin
epitaph, was kinder: 'He left scarcely any
genre of writing untouched, and touched
nothing that he did not adorn.'

106
The Brothers Grimm
German Popular Stories by J. & W. Grimm
Illustrated by Cruikshank, 1823
Cup.402.b.18, title page

This is the godfather of comparative
folklore as well as children's literature.
This English edition of their fairy tales is
vastly important both for its influence and
its almost perfect etchings by Cruikshank.
The brothers Grimm, Jacob Ludwig
Carl (1785–1863), and William Carl
(1786–1859) were pioneers of the study
of German philology, law, mythology
and folklore, as well as children's stories.
From this German book much English
fiction and fantasy for children sprang.
You can recognise its influence in Walt
Disney and Tolkien.

And there came the Beetle, so blind and so black,
Who carried the Emmet, his friend on his back.

And there came the Gnat, and the Dragon-Fly too,
And all their relations, Green, Orange, and Blue.

107

The Arrival of Sweetness and Light

The Butterfly's Ball, 1807
by William Roscoe
C.40.a.57, unpaginated opening

Children's books in England can be said to have had their origins in the anxiety of seventeenth-century Protestants to rescue children from hell, or from Rome, which was synonymous. This book arrived as a revolutionary relief from hellfire and moralising. It is fun and fantasy:

 Come take up your Hats, and away
let us haste,
 To the Butterfly's Ball, and the
Grasshopper's Feast.
 The Trumpeter, Gad-fly has summoned
the Crew,
 And the Revels are now only waiting
for you.
 So said little Robert, and pacing along,
 His merry companions came forth
in a Throng...

The black beetle gives the emmet (ant) a piggy-back to the party. Moth, wasp, hornet and bee join the creepy-crawly picnic. The grasshopper dances a lop-sided minuet with the snail. It was written by William Roscoe (1753–1831), lawyer and banker, book-collector, writer, scholar and botanist. He published his early verses when he was 24, and from then until the end of his life, many works of poetry, biography, jurisprudence, botany and arguments against the slave-trade. But he is remembered for this poem, which became a children's classic. It is the Adam and Eve of anthropomorphic animal fantasy for children, and the ancestor of Ratty and Mole, Hobbits and *Charlotte's Web*, and the rich Hollywood genre of treating other animals as human.

108
Head-Raising Device for Bibliophiles

Picture Book: Teachings for Children
by an anonymous Japanese author
illustrated by Okada Gyokuzan, 1803
Or.65.c.19, vol.3m, ff. 4v–5r

Son Kyō (an ancient Chinese scholar, Sun Jing) is reading in bed by means of this uncomfortable bookman's aid that he has invented. A rope suspended from the ceiling lifts up his head to prevent him falling asleep. This is an illustration to a didactic book produced to teach children the Buddhist and Confucian manners and way of life. Many of these illustrated moralities were derived from Chinese sources, and published in Japan from the seventeenth to the nineteenth centuries.

Their purpose was to inculcate in children (and women) Confucian ethics and etiquette. So they should be loyal, filial, frugal, hardworking citizens, and studious even in bed. The succinct Chinese text above (with extensive Japanese translation below it) reads: 'Sun Jing was so devoted to learning that he would shut the door and let nobody in.' Every schoolchild knew such books in their day. But they have become rare. The British Library holds two complete copies.

109
The Cat that Walked by Himself
Just So Stories by Rudyard Kipling, 1902
Add. MS 59840, f. 178

Beloved, the *Just So Stories* are animal stories for young children by Rudyard Kipling (1865–1936). They give amusing and fanciful answers to such questions as why the leopard has spots or the elephant a trunk. Originally intended for his young daughter, who later tragically died of fever, Kipling's stories were published in 1902 and they have proved timeless. His tales for children – he also wrote *The Jungle Book* and *Puck of Pook's Hill* – are his most durable achievements, or at any rate his most uncontroversial. Kipling himself drew the original illustration for his tale of 'The Cat that Walked by Himself'.

110
The Big Old Bear who Swallowed a Fly
by Trish Phillips, 2006
LC.31.a.2521

This is a modern variant of the traditional children's nonsense song:

There was an Old Woman who
swallowed a fly.
I don't know why she swallowed a fly.
Perhaps she'll die…

The Old Woman swallows a spider ('that wriggled, and jiggled, and tickled inside her') to catch the fly. She then swallows in succession a bird, cat, dog, goat and cow to catch their predecessors down her throat. Finally, she swallows a horse. 'She's dead – of course.' This modern reworking of her story has zany humour, pop‑up pictures, and a happy ending.

111 >>
A Modern Master
Quentin Blake's ABC, 1989
LB.31.c.409

This is the immediately recognisable work of the man with the magic pen. Quentin Blake (born 1932) is the artist who brings to life children's favourite characters, from Mister Magnolia to Willy Wonka in Roald Dahl's *Charlie and the Chocolate Factory*. He has illustrated more than 300 books, but it is his collaboration with Dahl that has made him an international star, loved from Java to Jamaica. He starts with ink lines scribbled fast, but with a very precise stroke. 'I put a sheet of watercolour paper over the rough and then, because I can see where everything has to go, I can draw as if I was making it up for the first time.' His artistic system of allowing himself a free hand at first, then tracing it, and working it up and colouring it, gives his work its spontaneity. There is also a humorous genius behind the racing pen.

LONDON COUNTY
ATHLETIC GROUNDS
HERNE HILL, S.E.
A few minutes' walk from Herne Hill Station, L.C.D. Railway. Frequent Trains and Omnibuses.

TUESDAY, JULY 9th, 1895,
SEVENTH ANNUAL
MUSIC HALL SPORTS
IN AID OF THE
Music Hall Benevolent Fund.

£300 IN PRIZES.
MILITARY BAND,
Under the direction of Mr. W. G. EATON.

OVER 20 EVENTS!
Admission - ONE SHILLING.
Reserved Seats, 2s.6d. Special Reserved Seats, 5s.
Vehicles, Two Wheels, 2s.6d. Four Wheels, 5s.
Occupants, 1s. each. Sports commence at 12 noon.
STAFFORD & CO , Printers, Netherfield, Notts.

12 Social History & Pastimes

112
Music Hall Sports, 1895
Poster for event at London County
Athletic grounds, 9 July 1895
Evanion 2821

This poster shows that modern athletes may run faster and jump higher than a century ago, but athletics is still the same old sport of grace under pressure. The walkers heel-and-toe like clockwork dolls. The runners in the steeplechase still step into the water. And the military band plays on. But the high-jumper seems to have invented the Fosbury Flop a century before Dick Fosbury revolutionised the sport at the Olympic Games in Mexico City in 1968. The poster advertises the athletics meeting at the London County Athletic Grounds, Herne Hill, in 1895. It comes from the Library's rich collection of pamphlets, handbills, and miscellaneous printed matter relating to Victorian life and entertainment.

People say that life is the thing. Some may prefer books. But all human life is preserved in the Library, not just the bookish and academic, but also the hearty and trivial. For it records the social history, recreations and pastimes of man from the beginning. The Victorian posters for early athletics meetings anticipate the events and even the styles of our present-day Olympic Games. More of the male runners sported moustaches a century ago, but their swinging arms and evident grace under pressure are contemporary. From 24 centuries ago, the Library holds the oldest letter. It was written by a Ptolemaic Greek Egyptian to his brother, but it refers to matters that are still topical for the modern email: money and the unreliability of snail mail. British archaeological wanderlust and collectors' craze brought the papyri of Egypt to London. They also brought the history and illustrations of that other English craze, tea. In fact modern Britons drink stronger brews than tea, but none stranger. The history of the British Empire can be read in the leaves of the fragrant oriental shrub, from China to India.

Philately is as traditional and English a craze as tea. The postage stamps of the United Kingdom are the oldest. Because they were the first, they are still the only stamps that deem it unnecessary to carry the name of the country that issues them. Philately is the hobby of kings and commoners and small children, and the Library contains the greatest stamp collection in the world, with remarkable mutations that vastly increase their value for collectors. As with stamps, London led the way with underground railways. The great Victorian underground works for railways and sewers are coming to the end of their useful lives, and being renewed. But are modern digging machines as revolutionary as those pioneering Victorian moles pictured herein?

The Library also holds a vast collection of newspapers, where one can read the first draft of history, from the earliest newsletters of five centuries ago to the latest versions from the red-tops and multimedia of today. And the earliest calendars in the Library set the pattern for the calendars and diaries still produced today in countless different formats.

The British Library leads the scholar and the curious backwards into the future. As one of the earlier authors held in the Library wrote: *Homo sum: humani nil a me alienum puto*. ('I am a man: nothing human is alien to me.') All human life is here.

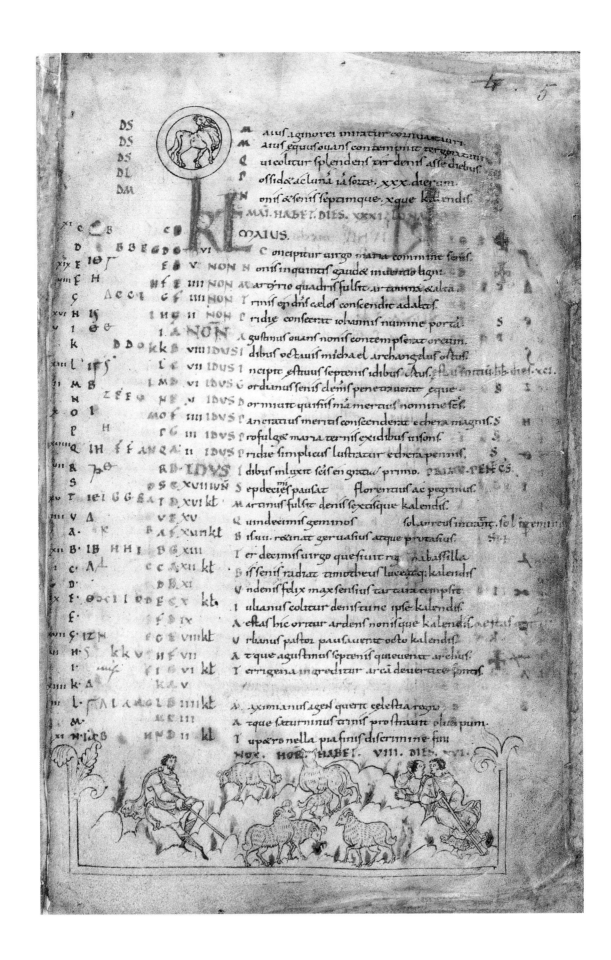

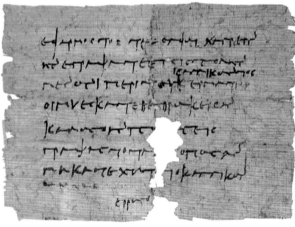

115
Letter From Epharmostos
Papyrus 2655

This papyrus letter was written in Greek in the third century BC by Epharmostos, who lived in Alexandria, Egypt. In his letter he complains to his brother Zenon, the royal finance minister in the ancient Egyptian city of Philadelphia, further up the Nile: 'Your last letter was eaten by mice.' It was found buried in the rubbish mounds at Oxyrhynchus (the modern el-Bahnasa in Egyptian Arabic) on the west bank of the Upper Nile. The ancient Greek name means 'sharp-nosed', after the Nilotic fish that was traditionally supposed to have eaten the penis of Osiris. Oxyrhynchus is the richest archaeological source of the past century. More than 70 per cent of our surviving literary papyri have come from these rubbish dumps. They include several comedies by Menander that have promoted his reputation to the premier division, fragments of poems by Sappho and Alcaeus, bits and pieces of many early non-canonical Christian gospels, and a large part of *Ichneutai* – 'The Trackers' – by Sophocles. Tony Harrison turned this into a modern English play: *The Trackers of Oxyrhynchus*. This fragment is bureaucratic rather than literary. But it is remarkably old. Most of the Oxyrhynchus papyri are Roman or Byzantine. The earlier levels were almost all destroyed, because they lay beneath the water-table of the Nile. This blast from the Ptolemaic past is unique.

<< 113
The Julius Work Calendar
Cotton Julius A.VI, f. 5

This is the earlier of only two surviving Anglo-Saxon work calendars. It shows the secular picture cycle of 'The Labours of the Months'. Possibly derived from a late classical model, it set the pattern for most later medieval (and modern) calendars of seasons of the year. It was written and illuminated, probably at Christ Church, Canterbury, in the early eleventh century. Each month is given a page. Each page is headed by a sign of the zodiac, with a list of the days of the month. In its 365 lines of Latin verse, the calendar recites the holy days and saints' days of the church's liturgical year, and miscellaneous information gathered from many sources. The names of the author(s) and illuminator(s) are lost in the backward abysm of time. This page shows the month of May, illustrated with the sign for Taurus, and reclining shepherds tending their flocks.

114
The Trewe Encountre, 1513
C.123.d.33, title page

The Trewe Encountre, or Batayle lately don betwene Englande and Scotlande is the earliest known English news pamphlet. It records the English victory over the Scots at Flodden Field in September 1513, in which King James IV of Scotland was killed. It was probably the largest battle between the two nations. *The Trewe Encountre* was printed by Richard Faques in London shortly after the news arrived. The copies known today have survived only by being used as parts of bookbindings. News pamphlets appeared from time to time in England during the sixteenth century, often to the annoyance of the government, and turned into regular papers (the ancestors of modern newspapers) in the 1620s. Walter Scott later wrote of 'Flodden's fatal field, / Where shiver'd was fair Scotland's spear, / And broken was her shield!'

116

Tea Picking in China
No. 2 in a series of prints, 1808
from the Silk Road Collection
Maps K.Top 116.19.2b

A curiosity of history is how this aromatic Oriental leaf became the national drink of England. Tea became the wonder commodity for the East India Company. The Company began to trade in Chinese tea in the 1650s, but it was not an immediate success. At the time, people in Britain drank ale for breakfast (water was largely unfit to drink), so there was a market gap for a non-alcoholic, thirst-quenching, warming drink. The illustration shows the intricate processes by which the fragrant leaves began their journey halfway round the world to the tea-tables of London. Before it became the national drink, tea was the drink for heroes and the aristocracy. Brewers, sensing competition, persuaded the British Government to tax

tea. Adulteration and smuggling were direct results. The first cup of American Independence was poured at the Boston Tea Party in 1773–74. From such a tiny teabag dunked by the smugglers into Boston harbour did the mighty American Empire grow. Samuel Johnson described himself as: 'A hardened and shameless tea-drinker, who has for 20 years diluted his meals with only the infusion of this fascinating plant; whose kettle has scarcely time to cool; who with tea amuses the evening, with tea solaces the midnight, and with tea welcomes the morning.' Tea fuelled our merchant navy as well as our dictionaries. The tea clippers to bring the little leaves from China were the Concordes of the first half of the

nineteenth century, the fastest transports of delight on the seven seas. William Cobbett found it necessary to advise the City Yuppies of 1829 to free themselves from the slavery of the tea and coffee and other slop-kettle. Once the Company had access to Canton and the political issues were settled, and the United States had won independence, tea-drinking took off. Green varieties were favoured initially, but black teas soon took over in popularity. The English invented tea ceremonies as intricate as any of those in countries that actually grow tea. Milk or tea first? Lapsang Souchong or Earl Grey? Who but the English would pollute the delicate flavour of tea with cow juice and lumps of sugar? Actually Indians too.

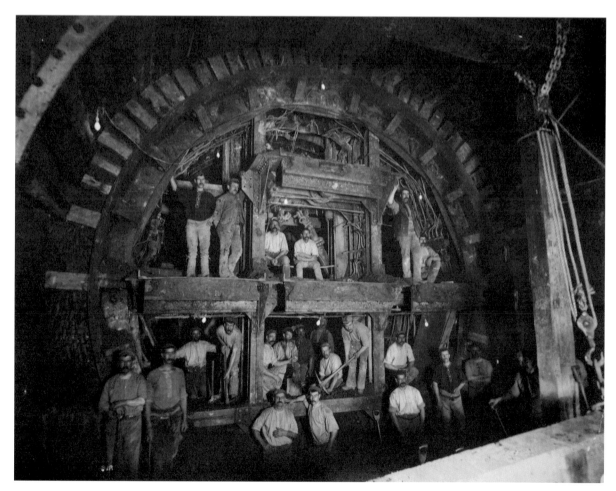

117
**Construction Work
on the London Underground**
Unknown photographer, 1898
Photo 1132/1

Mainline locomotives first puffed in Great Britain. So did underground railways. On 10 January 1863, the world's first public passenger-carrying underground railway, the Metropolitan, opened the gates of its stations to Londoners. Its route, from Paddington to Farringdon Street in the City, was not much more than 3¾ miles long, but there were queues on that first day to see the new marvel. In the first six months 26,500 passengers a day used it. These early underground railways were constructed by the 'cut-and-cover' technique – digging a trench, then roofing it. This is a photograph of the Greathead tunnelling shield, another marvel of Victorian engineering. It was developed from

pioneering projects such as Brunel's Thames Tunnel. The tunnelling shield prevented collapses by pouring in concrete as the earth was dug out. Well done, old mole. Canst work i'th'earth so fast? A worthy pioneer. The shield was used for the excavation of all London's deep level (or 'tube') lines. The first such line was opened in 1890 – the City and South London, now part of the Northern Line. In this photograph, it is tunnelling to create the Central Line's Museum station, which served the British Museum from 1900 until the station's closure in 1933. London still has the most extensive network of deep tube lines in the world. It is also the oldest, and badly needs extensive renewal.

118
Street Map
of Jewish East London in 1899
04034.ee.33

This map covers Whitechapel, Mile End, Bethnal Green and Shadwell. Here the latest Jewish immigrants from Russia and other parts of Eastern Europe settled throughout the nineteenth century, and made a living, chiefly from the rag trade. It includes Cable Street, the scene of the famous 'Battle' of 1936, when Oswald Mosley and his followers in the British Union of Fascists and National Socialists were turned back from their planned march through the Jewish quarter by residents and anti-fascists. The Battle of Cable Street marked the end of Fascism as a political force to be reckoned with in Britain. And the recognition that Londoners come in all colours, races and creeds that cannot be mapped by streets, even in the British Library. We are all Londoners.

119 >>
The Penny Red Stamp
Great Britain, 1858-79, unused
Tapling Collection: Red Plate 77

Postage stamps were invented in Great Britain. Previously recipients paid to receive their post. And the charges were calculated according to such factors as distance carried and number of sheets of paper. In 1837 Rowland Hill, a teacher who interested himself in the egalitarian schemes of Robert Owen, introduced his Post-Office Reform Bill. This advocated a uniform penny rate of postage, to be prepaid in stamps, between places in the British Isles. The royal mail was to be a government monopoly, in order to facilitate commerce and postal communication. Like the Persian couriers, not snow, no, nor rain, nor heat, nor night was to keep the British posties from accomplishing their appointed courses with all speed. The first postage stamp, the Penny Black, was sold on

1 May 1840. But it was in use for little over a year. It didn't take long to ascertain that a red cancellation on a black stamp was hard to see; and that it was easy to clean the red mark from the black stamp in order to reuse it. This deprived the Post Office of revenue. So in 1841 the Treasury switched to this Penny Red. It was cancelled with black ink, which was much easier to see. Here is Queen Victoria in her fifties, philatelically and rosily endowed with eternal youth. The British Library holds the first and greatest collection of stamps in the world, including all of Victoria's adhesive postage stamps. This one comes from Printing Plate 77, which was rejected as unsatisfactory. By the little accidents of printing, a few copies somehow reached the public and hence the Library.

THE MAFEKING MAIL
SPECIAL SIEGE SLIP.

ISSUED DAILY, SHELLS PERMITTING. TERMS: ONE SHILLING PER WEEK, PAYABLE IN ADVANCE.

No. 70 — Saturday, February 10th, 1900. — 121st Day of Siege.

The Mafeking Mail.
SATURDAY, 10th FEBRUARY, 1900.

LADYSMITH RELIEVED?

Although there is no definite information to hand about Ladysmith, one may adopt, with feelings of confidence, the assumption that its relief has already been effected. We think on or about Wednesday, the 24th January. Space will not permit of giving the various pegs upon which to hang that belief, but Buller's advance on the 17th, the report of fighting at Spions Kop, on the 22nd and 23rd, the statement made in the paper of the 26th as to fighting having taken place 30 or 40 miles North of Ladysmith, the particular viciousness of the Boers here on the 27th to 31st. The London wire of the 2nd February telling of the upward bound on the Stock Market, all suggest that there is good news for us somewhere on the road.

With deep regret we record the death of Mr. James Dall, Town Councillor. All Mafeking will join in heartfelt condolence with his family in this their hour of sorrow and bereavement, and none will withhold tribute to the sterling integrity, the intense devotion as husband and father, and the worth of our late townsman.

POSTPONEMENT.

We are desired by Mr. Feltham, who is acting as Secretary to the Bachelor Officers Dance Committee, to state that as a tribute of respect to the family and friends of the late Mr. Dall, the dance announced for this evening will be postponed till to-morrow.

AUCTION SALE.

The undersigned, duly instructed, will sell by Public Auction, on

Sunday Next,
At 10-30 a.m.,

A quantity of Ladies and Mens Boots and Shoes, Mens Underwear, Trousers, Jackets, Shirts,

And many other articles too numerous to mention.

Also a lot of New and Second hand Novels.

In addition to the above a lot of GOOD SECOND HAND CLOTHING ABSOLUTELY NO RESERVE!

Don't fail to receive Bargains.

Aldred & Ross,
Auctioneers & Sworn Appraisers.

With the sanction of the Col. Commanding

CYCLE SPORTS
will be held at the

RECREATION GROUND,
— on —

Sunday, February 11th,
Commencing at 2-30 p.m.

Lady Sarah Wilson has kindly consented to distribute the prizes, which comprise: Watches; a Clock; a most handsome hand-painted "Watteau" Fan; Silver Glove Buttoner; Candlestick Mirror; Silver mounted Pipes; Amber Cigarette Holders; Cigarette Cases, &c.

Referees H. H. Major Goold Adams. *Judges*: Major Godley; Capt. Cowan. Inspector Marsh. *Handicappers* Lieut. Colonel Walford Inspector Browne. *Starter* C. G. H. Bell, Esq., C.C. & R.M. *Clerk of Course*; To be appointed on *Lap Scorer* the Ground.

The Totalisator
Will be upon the Grounds.
Under charge of Serjt. Major Merry.

PROGRAMME:

	Start
1. One Mile Siege Championship	2-40
2. Team Race of One Mile	3-0
Four members of: The Prot. Regiment, the B.S.A. Police, the Cape Police, the Bechuanaland Rifles, and the Town Guard.	
3. Half Mile Bicycle Race in Fancy Costume.	3-20
One prize for Winner, and one prize for best Fancy Dress.	
4. Half Mile Ladies Race	3-40
5. Three Lap Race	4-0
Walk a lap. Ride a lap. Run a lap.	
6. One Mile Bicycle Handicap	4-40
POST ENTRIES.	

Bicycles will be provided for those who have not their own. Lots being drawn for them.

The distribution of Prizes will take place directly after the last race.

By the kind permission of Capt. Cowan the Band of the Bechuanaland Rifles will play during the intervals.

Book Early for the
Concert.
Plan rapidly filling up.

Only a few Reserved Seats left.

ALDRED & ROSS, Market Square.

GRAND SIEGE CONCERT
UNDER THE PATRONAGE OF

Colonel R. S. S. Baden-Powell and Officers of the Garrison,

AT THE

MASONIC HALL,
February 11th, 1900,

TO CELEBRATE
THE 18TH SUNDAY OF THE SIEGE.
Commencing at 5-30 p.m.

Proceeds to be given to the Sports and Prizes Funds.

PROGRAMME:
PART I.

1. Cape Police, O. H., Khaki Band
2. Song ... "Anchored," Mr. Campbell
3. Pianoforte Recital, Signor Paderewski.
4. Song, "At the Ferry," Miss Friend
5. Mandoline Solo, "Mary" Waltz, Pte. J. P. Murray
6. Song, "Beauty's Eyes," Mr. Bulleid
7. Siege Song ... Pte. K. W. Coxwell
"If it wasn't for the Maxim in between,"

Interval of 5 Minutes.

PART II.

1. Piccolo Solo ... Mr. Westland
2. Lager du main ... Mr. F. J. Jacobs
3. Song, "Sunshine above," Capt. Ryan, D.A.A.G.B.
4. Recitation, "Bill Tinks," Lieut. C. N. McKenna.
5. Siege Sketch ... Gentleman Joe
6. Song, "The Outpost," Mr. Campbell
7. Comic Song ... Pte. K. W. Coxwell

God Save the Queen.

Owing to time no encores will be allowed.

HURRAH !!
Here is something Good.

F. FIRTH
Has still some hundreds of

Pianoforte Pieces and Songs
AT 4 COPIES FOR 1s.

ACCORDEONS
At 16s., 17s. 6d., 20s., 30s., 32s. 6d.

MAFEKING MUSIC DEPOT.

Printed and published by Townshend & Son, Market Square, Mafeking Editor and Manager: G. N. H. Whales.

120
Special Siege Edition of the Mafeking Mail
'121st day of siege'
No.70, Saturday 10 February 1900

The Mafeking Mail was restricted because of the siege conditions in this South African town during the Boer War (1899–1902). As this issue of the newspaper states on its front page: 'Special siege slip. Issued daily, shells permitting'. It was printed on any materials that came to hand, from accounts paper to brown wrapping paper. The relief of Mafeking after 217 days produced public celebration in Britain, a symbol of the new imperial unity forged in the war, and the verb 'to maffick', meaning 'to rejoice with hysterical boisterousness'. The British Library's mountainous treasure house of newspapers runs from the first newsletter of 1513, and includes outstanding collections from the birth of the inky trade in the seventeenth and eighteenth centuries. They were largely collected by George Thomason (d. 1666), a London bookseller, and Charles Burney (1757–1817). The Newspaper Collection is the greatest store in the world of the topical news that occupies the daily and weekly attention of millions. It includes the earliest examples of newsbooks: 'A true report of certaine wonderful overflowings of waters' (1607) has a picture of floods that is the grandfather of today's television shock-horror images. The Corantos, such as 'Corante, or newes from Italy, Germaine, Hungarie, Poland, Bohemia and France' (1621), based on the Holy Roman Empire's newsletter system, are the ancestor of today's news agencies. Woodcuts were used in advertisements as early as 1786. A spectacular example can be seen in *The Times* of 7 April 1806: the detailed ground-plan of a house was printed on the front page in order to illustrate a sensational murder. (*The Times* was nicknamed *The Thunderer* sarcastically, mocking its sensationalism, not its radical politics.) Newspapers are by definition ephemeral. But they are also history in print. And the library holds the greatest history of the print.

Credits & Acknowledgements

A note on the typefaces

A combination of typefaces was chosen to suggest both the history of the British Library and its future as a forward-looking world-class resource. The serif typeface used for captions (and these words) is Poliphilus, a facsimile of the text in *Hypnerotomachia Poliphili*, a famous early printed book published by Aldus Manutius in Venice in 1499, after which the face is named. The italic is *Blado Italic*, which was cut to accompany Poliphilus. The display face (also used for the introduction, chapter introductions and caption information), is Foundry Form Sans, designed recently by Freda Sack at Foundry Types Ltd.

Acknowledgements

The author and publishers are indebted to the following for suggesting items included in this book and/or providing information on them: Brian Alderson, Peter Barber, Nicolas Bell, Penny Brook, Yu-Ying Brown, Debbie Cox, John Falconer, Tony Farrington, Annabel Teh Gallop, John Goldfinch, Jaap Harskamp, Patricia Herbert, Jana Igunma, Vrej Nersessian, David Plumb, Andrew Robinson, Richard Scott Morel, Hedley Sutton, Judith Tranmer, Marian Wallace and Frances Wood.

Kathleen Houghton worked tirelessly to source the photographs required.

The British Library is grateful to Sir Paul McCartney for permission to reproduce the manuscript of 'I want to hold your hand'.

Photographic credits

Front cover: Elizabeth Hunter
Page 2: Oliver Craske
Page 6: Gerhard Stromberg

All other photographs are supplied by the British Library.

Further information about the British Library can be found at: www.bl.uk